# PAINTING ANIMALS

To my son Galaad
To Marguerite and my parents

With special thanks to Guillaume, Françoise, Bruno and all the team at Fleurus, to Marguerite, Frédéric and Maille Chauvineau, to Valéry Marche and Philippe Hertel of Vol Libre, to Yago Four Wolves, to Éliane and Yohann Lavigne, to Pascale and Hugues Fanal, to Didier Langevin, to James Rousseau and to the team at Dupon Bastille, and also to Claude Fradkin.

Ch. D.

First published in the UK in 2006 by
New Holland Publishers (UK) Ltd
London • Cape Town • Sydney • Auckland

Garfield House, 86–88 Edgware Road, London W2 2EA
www.newhollandpublishers.com

80 McKenzie Street, Cape Town, 8001, South Africa

Level 1, Unit 4, 14 Aquatic Drive, Frenchs Forest, NSW 2086, Australia

218 Lake Road, Northcote, Auckland, New Zealand

Original title of the book in French: *La Peinture Animalière*

ISBN-13: 978 1 84537 545 4
ISBN-10: 1 84537 545 9

10  9  8  7  6  5  4  3

**For Fleurus**
**Author:** Christophe Drochon
**Text:** Françoise Coffrant
**Editorial Director:** Christophe Savouré
**Editor:** Guillaume Pô
**Artistic Director:** Laurent Quellet, Isabelle Mayer
**Photographer:** Bruno Gosse

**For New Holland Publishers**
**Project Manager:** Corinne Masciocchi
**Editor:** Anne Konopelski
**Translator:** Gilla Evans

For more information about Christophe Drochon:
www.drochon.com

CHRISTOPHE DROCHON

# PAINTING
# ANIMALS

TEXT BY FRANÇOISE COFFRANT

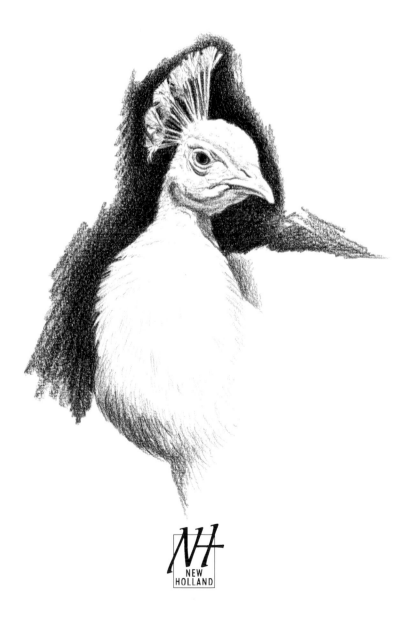

NH
NEW
HOLLAND

# Contents

*King Lear* (3/4), acrylic on fibreboard, 28 x 29 cm (11 x 11½ in).

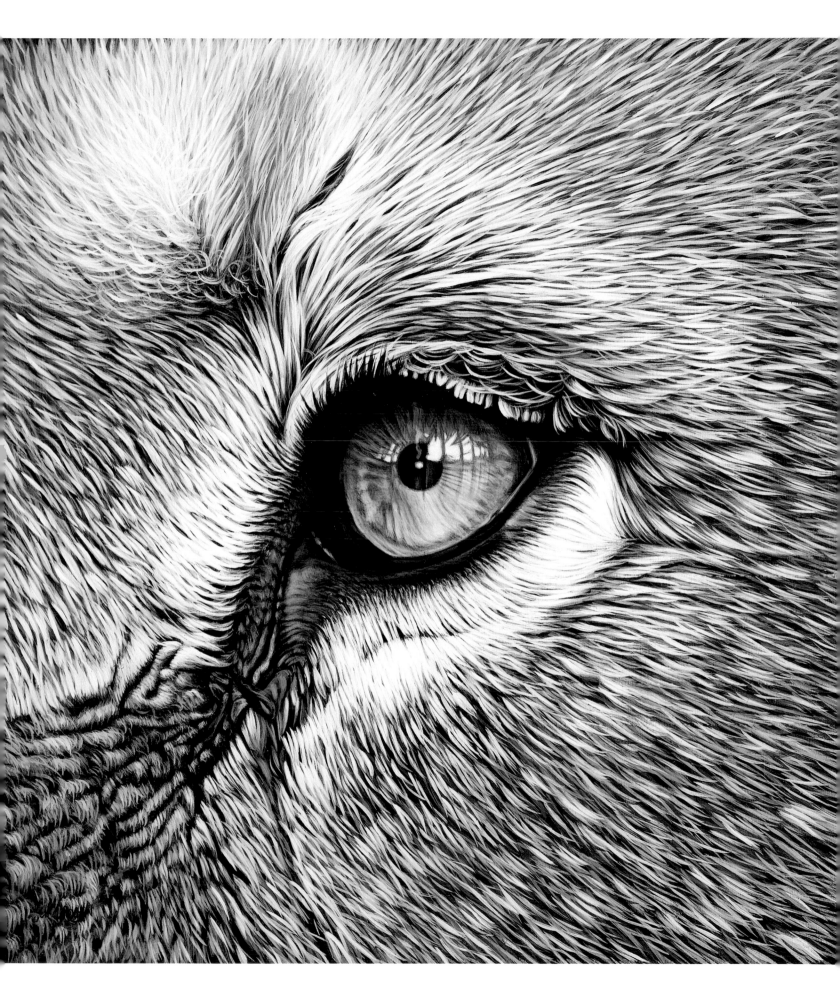

The first impression is one of astonishment. A bright clear eye looks intently at the viewer. Dense, spotted or silky fur surrounds the troubled gaze of a big cat. An imperial eagle spreads its wing and cranes its neck. The attitude is enigmatic or tender. Christophe Drochon invents a fabulous bestiary, conveying a dreamlike, mythical, ideal and vanished world with names such as *King Lear, Galahad, Jade Spring or Holy Spirit…*

The skill of the artist is breathtaking. The precision of his brushstrokes and the accuracy of his colours make each composition a unique work of art. These are not really hyperrealist paintings however. Their formal perfection is intended to convey the artist's message – a message that is also carried by the setting, the surprising compositions, the striking effects of light, the special concentration on certain areas…

The animal that he paints belongs to the real world, and yet the subject of the painting is of another world. The lion, turtle dove and eagle owl are vehicles of a story in which personal memories and metaphysical questions are inextricably intertwined. Mythology, religion and popular traditions are sometimes invoked. These are not mere symbols however, for the artist is inviting us on a spiritual quest. His work springs from a deep personal emotion. Presented to the viewer, it becomes a reflection on mankind and on its essential values.

*Galaad*, acrylic on canvas, 81 x 65 cm (32 x 25¾ in).

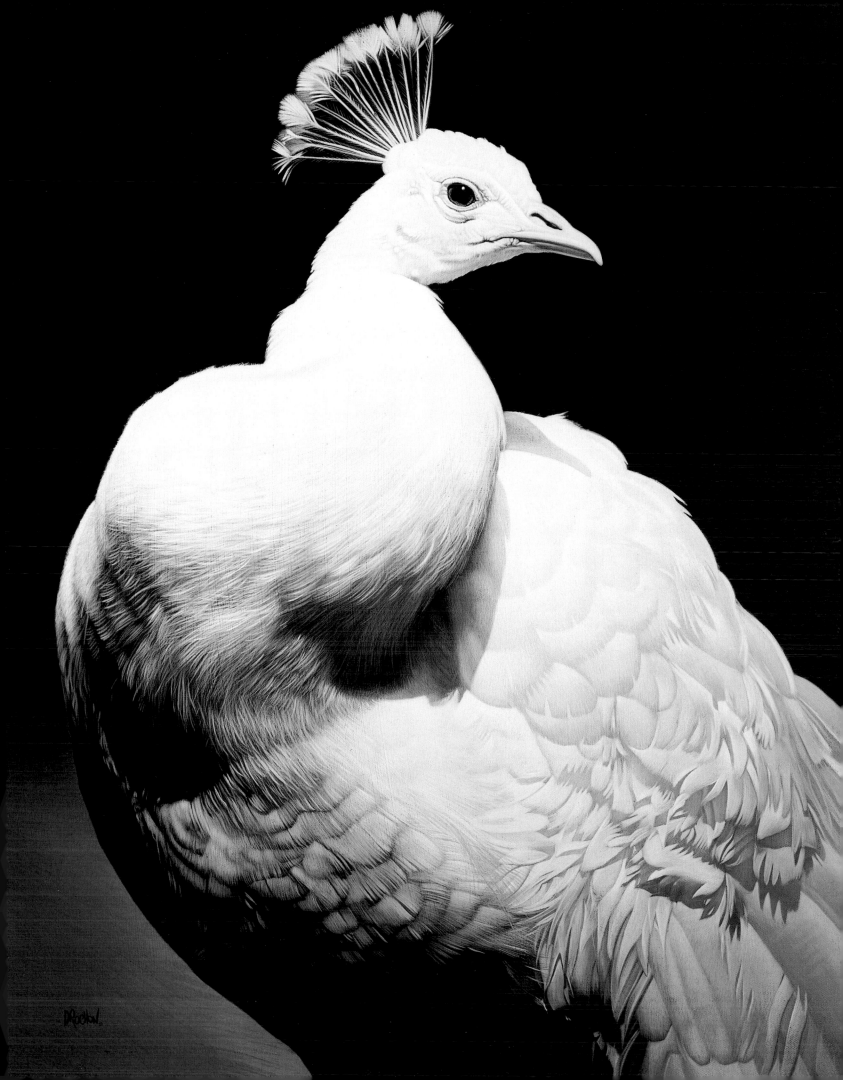

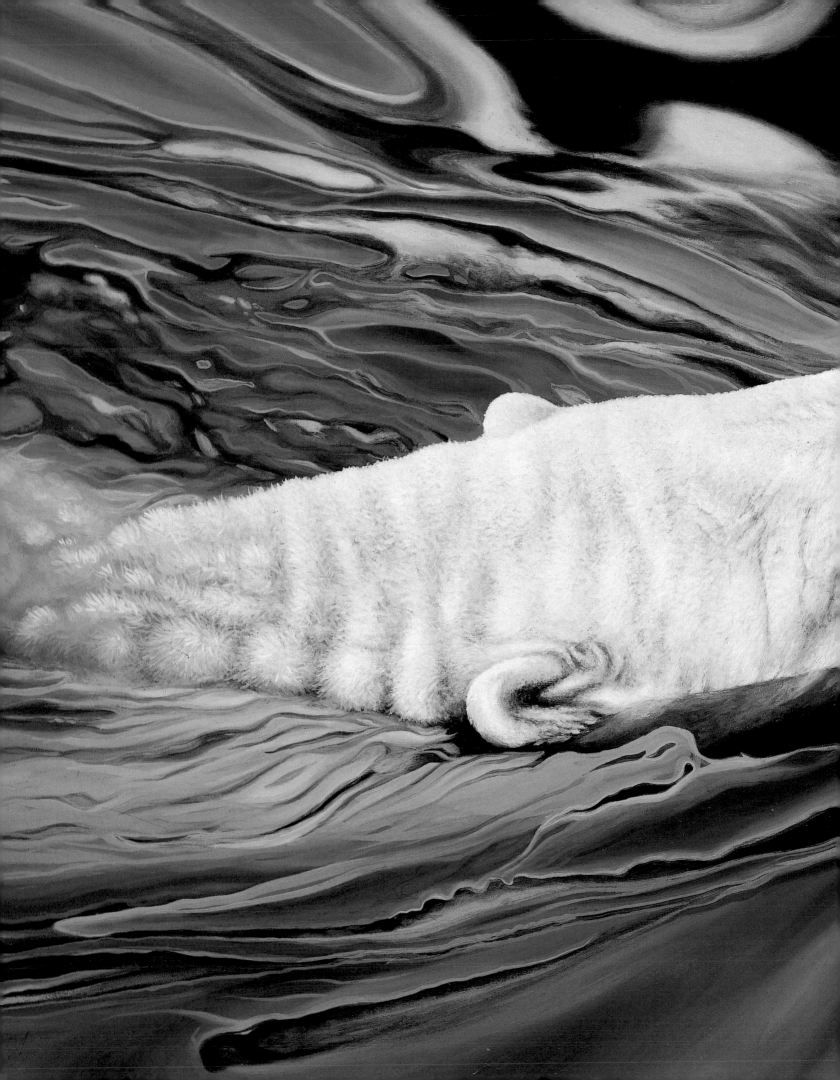

# Techniques

# In the field

Out in the woods or in the countryside, the artist becomes very keen-eyed. His senses are on the alert. An encounter with an animal in the wild, however brief, gives him infinitely more information than hours spent with an animal in captivity. Indeed, although it is vital to study the form and structure of the animal, it is just as important to get to know its habitat and its behaviour. To paint an animal well, it is not enough to observe the animal, you have to try to understand it. It is the emotion arising from this exchange that determines the form the work of art will take.

## Sketches

A sketching session, one of the most enjoyable stages in the artist's work, provides an opportunity to get out and about and recharge your batteries in natural surroundings. Christophe Drochon lives close to the forest of Trois Pignons, part of the Fontainebleau forest massif in France. It is an excellent place for walking and for contemplation. He spends a lot of time there, making sketches on several pages of his notebook: rocks in the sun, birds in the trees, landscapes. He concentrates on contrasts of dark and light, creating almost abstract forms.

Christophe Drochon uses spiral-bound sketchbooks of lightweight fine-grained paper (125 gsm), either 210 x 297 mm (8¼ x 11¾ in) or 297 x 420 mm (11¾ x 16½ in). On this very slightly rough medium, the line is more expressive than it is on smooth paper. His main tools are HB pencils and Conté pierre noire in a propelling (mechanical) pencil. He also uses a fixative spray. For making notes on colour, he sometimes takes pastels, a small box of watercolours, a paintbrush, a water container and a cloth. A pair of binoculars, a camera and occasionally a small folding stool complete the kit of this tracker of images.

An animal does not pose; it moves, albeit sometimes imperceptibly. Its muscles are constantly in motion, its skin quivers. Sketching enables the artist to quickly mark a line to suggest a position or an impression felt in front of the model. He can set down a thought, an idea that can be developed later on in a finished piece of work. Sketching is an art of taking notes in more or less heavy lines, sometimes emphasized with a little shading.

The artist rapidly outlines the contour of a deer's head, the curves of a hawk's wings, the silhouette of a swan. These sketches are done in a few seconds. Depending on the pressure he exerts on the Conté pierre noire, he can obtain a variety of expressive lines. The observation is extremely rapid, the eye confidently guiding the hand. Christophe Drochon does not go back over a mistake, he begins another sketch.

■ **Caracara**. The small black lines on the bird's neck give a sense of the softness and density of its plumage.

Conté pierre noire on paper, 34 x 25 cm (13½ x 10 in).

■ **Snowy owl in flight**.
The movement of the wings is suggested in a few pencil lines.

Conté pierre noire on paper, 17 x 18 cm (6¾ x 7 in).

# Drawings

In a zoo or wildlife park, the artist can sit down comfortably and make more detailed drawings. Here it is easier to study the form of an animal because of its proximity to the observer, even if he sometimes has to use binoculars. In enclosures, the distance separating him from his subject varies according to the species. He takes account of the direction of the light and the contrasts and reflections on the coat or plumage of the animal he is drawing.

To convey all these nuances, Christophe Drochon works on 180 gsm slightly rough paper, which is ideal for hatching and cross-hatching. He begins by drawing the outline of the subject with a light line, then positions the shape of the eye, the most important feature. He adds shading to determine the form of the animal. With small lines, more or less close together, he makes it three-dimensional. To accentuate the shading, he crosses the first hatching with additional hatching, bringing it further into relief. Using this method, the artist obtains a whole range of tones, from pale grey to deepest black. He often emphasizes the animal's presence by surrounding it with a very dense black background.

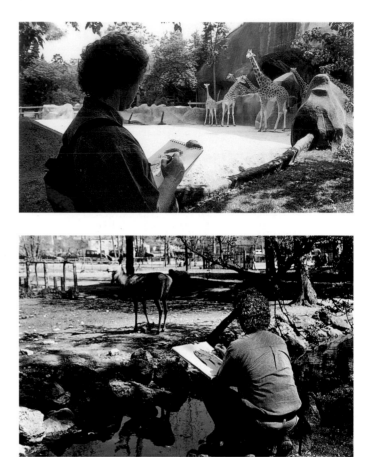

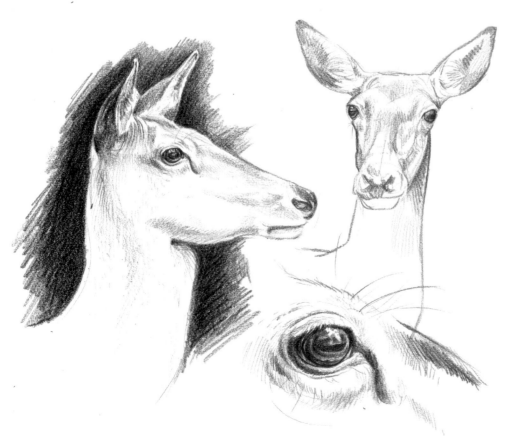

■ **Studies of does**. The modelling has to convey the tension of the muscles, the vibrations of the light on the glistening fur, the soft shadows.

A whole range of greys is obtained with different degrees of hatching. Spaced out and loose along the neck, it suggests the supple texture of the animal's skin. Fine and intersecting, it gives the illusion of volume on the muzzle and under the jaw. Around the eye and on the skull, the slant of the stronger hatching gives a sense of the way the fur grows. The back of the ears, in shadow, is filled with a uniform dark tone. Rimmed in white, the upright ears stand out against the black background. On the very black iris of the eye, small white shapes create glints that give life to the eye's gaze.

Conté pierre noire on paper, 25 x 30 cm (10 x 12 in).

■ **Stag**. In this drawing of a majestic stag, stress is placed on the thickness and length of the hairs on the neck. Vigorous lines drawn with Conté pierre noire follow the movement of the fur. The shorter fur on the back and hindquarters is sketched with small lines rounded on the top to follow the shape of the animal's muscles. The antlers are lit from above and strongly shaded underneath.

Conté pierre noire on paper, 19 x 21 cm (7½ x 8¼ in).

■ **Portrait of a doe**. The artist begins by applying light greys using the side of the pencil lead. He accentuates the shading with closer hatching. A sense of volume is produced by a gradual deepening of the shadows from light to dark. The black background creates atmosphere and helps make the subject of the drawing stand out.

Conté pierre noire on paper, 26 x 22 cm (10¼ x 8¾ in).

# Watercolours

Watercolour paint is composed of transparent pigments mixed with a binding agent, usually gum arabic. An art practised since ancient times, watercolour painting developed in the Middle Ages in the art of illumination, then was used to colour wood engravings. Over the centuries, watercolours have always been part of the painter's toolkit, used for making notes and sketching ideas. Complementary to drawing, watercolours allow the artist to add light, shade and contrasts. Travellers exploring the world have always carried watercolours, and they are used by nature lovers and anyone with a keen sense of curiosity.

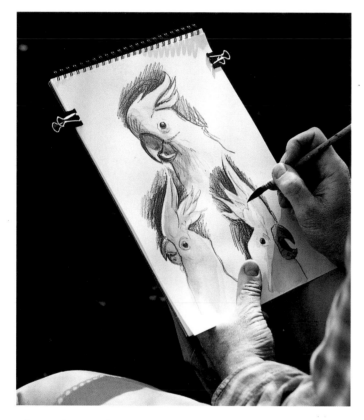

Christophe Drochon's work follows in this tradition. As he looks for subjects for his paintings, he uses watercolours both for sketches and for more detailed studies. His sketchbooks are filled with animals painted in light shimmering colours. This allows him to reproduce the bright colours of a plumage, the golden glints in the eyes of a leopard and the russet and tawny colours of a fox later in the studio.

The artist draws on a medium-sized block of 125 gsm or 180 gsm fine-grained paper. His lightweight kit includes an HB pencil, a sharpening knife, a rubber (eraser), a small box of 12 artist's watercolours with a water reservoir, a pot and small paintbrush, and some cloths. This simple kit is compact and easy to carry.

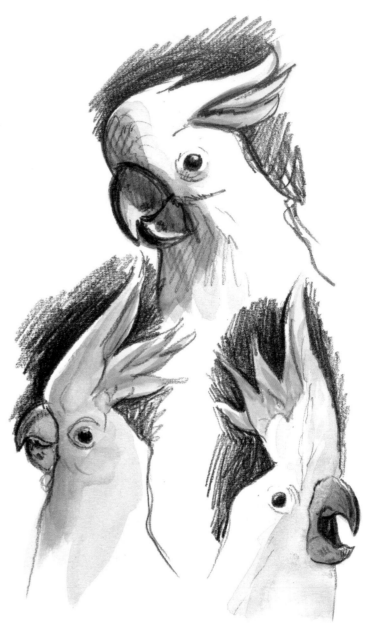

■ **Cockatoos**. In this study of cockatoos, attention has been paid to the shape of the bill, which is short, stout and hooked. The line of Conté pierre noire is strong. Depending on the bird's posture and the viewpoint, the crest of yellow feathers looks different, and rather disorderly. The lines are marked quickly, with a black ground for emphasis. Contrasts are added lightly with layers of blue and grey watercolour washes. The crest feathers are emphasized with a few bright yellow brushstrokes on a pale lemon yellow ground.

Conté pierre noire and watercolour on paper, 29 x 17 cm (11½ x 6¾ in).

■ **Black-headed caique**. The artist has expressed the impertinent gaze of this caique with a flash of bright light in its round eye. The bright light colours of its body stand out against the grey of its head and the deep green of its wing. The contrast creates a sense of volume. This rapid sketch, with its sunny yellow background, is full of life.

Conté pierre noire and watercolour on paper, 23 x 13 cm (9 x 5¼ in).

■ **Fawns**. Two young fawns stride along the forest edge. Their silhouettes are accurately drawn in pencil. A light wash of pale yellow and ochre watercolour suggests the expanse of the plain. The coats of both animals are conveyed with touches of very dilute Raw Sienna. The areas of shade in pencil emphasize the contours of their bodies. The trees, which are covered with a range of shades of green, create a three-dimensional background to the picture.

Conté pierre noire and watercolour on paper, 10 x 28 cm (4 x 11 in).

# Oil pastels

Oil pastels, made from pigments bound together with an oil and wax binding agent, produce an end result that is similar to oil painting. They are easy to handle. Christophe Drochon uses oil pastels in addition to his preliminary drawings; their bold and vivid colours rapidly give a sense of the attitude of his subject.

The ease of handling of these smooth pastels gives the artist a freedom that is very useful when drawing from life. He applies the colour to the surface of the paper with the pastel at his fingertips. He works quickly, almost by instinct. Using the colours next to and on top of each other allows him to create multiple textures to suggest the softness of an animal's coat or the brightness of an eye.

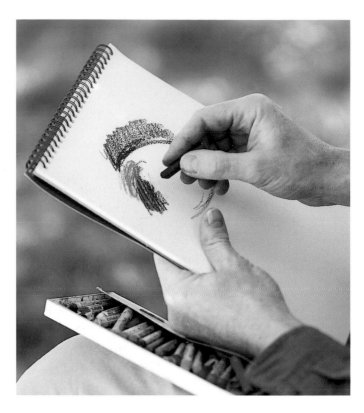

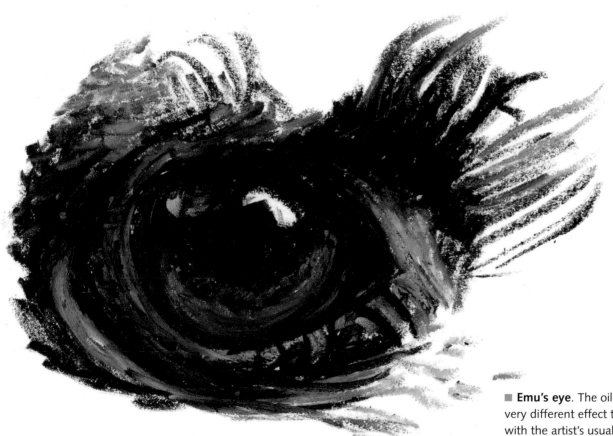

■ **Emu's eye**. The oil pastel creates a very different effect to that obtained with the artist's usual precise and realistic technique. Black, blue and red ochre lines intermingle to give a brilliant textural effect.

Oil pastel on paper, 9 x 11 cm (3½ x 4½ in).

■ **Demoiselle Crane**. On the Conté pierre noire drawing, layers of blue and black bring out the slender shape of the crane's neck. Vigorous lines suggest the layers of feathers. A line of red ochre emphasizes the point of the bill.

Oil pastel on paper, 27 x 13 cm (10¾ x 5¼ in).

■ **Zebra**. Using the sharpened edge of the oil pastel, the painter draws the zebra's characteristic stripes following the bone structure of its head and the muscles of its neck. The thick strong lines express the rhythm of the animal's coat.

Oil pastel on paper, 19 x 18 cm (7½ x 7 in).

# In the Studio

A den of creativity, the painter's studio does not need to be very big. Christophe Drochon is temporarily making do with a room 12 m² (129 sq ft) which he has managed to organize with great ingenuity. An architect's drawing table, a few storage cupboards... In this private world, the artist has all his materials to hand. He can dream, draw and paint on small and medium-sized formats. When working on larger canvases, he moves into a large room lit to the north.

## Supports

Christophe Drochon draws on watercolour paper, preferably grained and fairly thick (180 and 300 gsm). He paints on canvas, fibreboard or illustration board.

### Canvas

Both strong and flexible, canvas is mounted on a frame. The painter uses a fine-grained pure linen canvas, coated with a universal primer. To obtain the absolutely flat and smooth surface needed for his detailed work, he applies one or two thin layers of 10 per cent diluted gesso to his canvas, using a hog bristle graining brush. The brush strokes on the canvas must be made in both directions to obtain an even surface. After drying (which takes 30 minutes to 2 hours depending on the product used), the artist applies another layer of gesso. He leaves it to dry thoroughly, then rubs it down with a sanding block and extra-fine sandpaper. He removes any dust with a soft cloth. Canvas prepared in this way produces an absolutely smooth painting surface.

# Fibreboard

This is a panel of Medium Density Fibreboard (MDF), made using a dry process in which synthetic resins are added to wood fibres and then compressed into panels under high pressure. Even very thin fibreboard (4 or 5 mm/¼ in thick) is remarkably strong. It is easy to cut, without producing splinters. This support is perfectly smooth on both sides. To make it ready for painting, all it needs is the application of one or two layers of 10 per cent diluted gesso and rubbing down with extra fine sandpaper.

Applying gesso to a sheet of fibreboard.

# Illustration board

White illustration board needs no preparation. It can be made by pasting a grained or smooth paper onto high-quality acid-free card. Christophe Drochon uses this in small formats for his acrylic or gouache paintings.

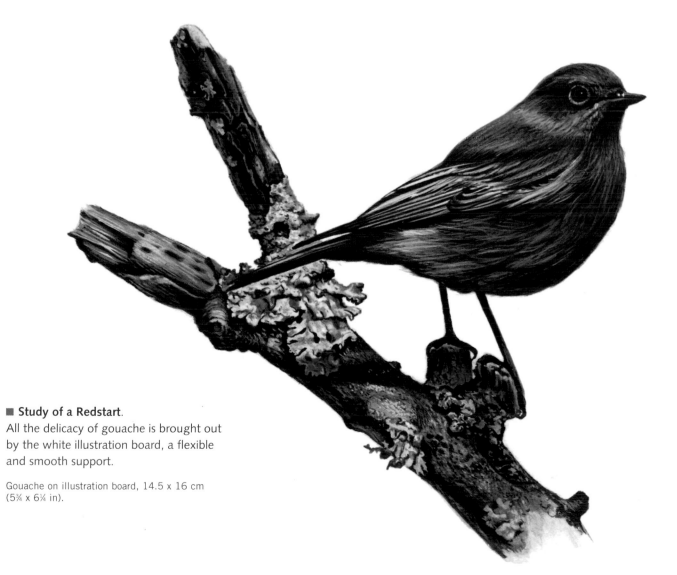

■ **Study of a Redstart**.
All the delicacy of gouache is brought out by the white illustration board, a flexible and smooth support.

Gouache on illustration board, 14.5 x 16 cm (5¾ x 6¼ in).

# Brushes

Different kinds of brushes are used for oil and acrylic paint to those used in wet techniques such as watercolour, gouache or ink.

Long flat brushes with hard bristles (hog bristles or synthetic fibres) are suitable for making broad strokes, applying solid colour and creating textural effects. Christophe Drochon uses this type of brush to paint his acrylic backgrounds and his first layers of oil paint, as well as to varnish his paintings. Short flat brushes give more rigid strokes, useful for the juxtaposition of colours.

Round, soft-haired paintbrushes made from sable or fitch are indispensable for very detailed work. They retain their shape even when loaded with paint. Their fine and flexible tip is particularly suitable for drawing the feathers and fur of birds and animals.

Christophe Drochon sometimes uses oval brushes, called "almond" or "cat's tongue" brushes, made from natural fitch or sable. These brushes have a flat head that gives a slightly rounded stroke. But he paints most frequently using worn and rounded filbert brushes made of fitch or sable. These brushes are slightly tapered at the side and rounded in the centre. The ferrule is flattened but the tuft of hairs is round. By using the rounded tip of the paintbrush, the painter is able to control the path of the line he is drawing perfectly.

A variety of brushes enables the artist to work with precision.

Holding the brush close to the ferrule helps the artist draw a straight line.

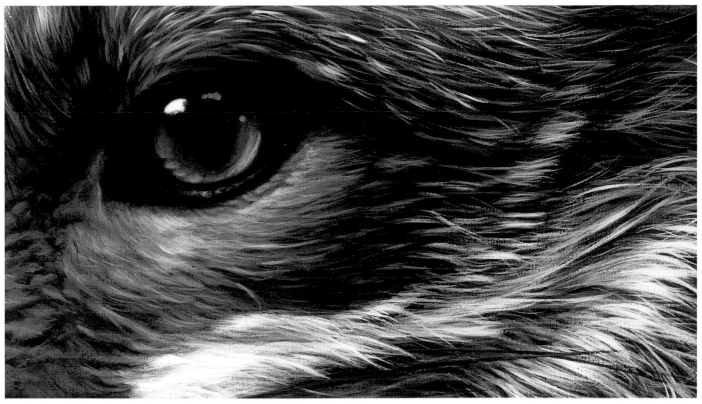

Detail of *The Ruffian, common fox*, acrylic on canvas, 18.5 x 22.5 cm (7¼ x 9 in).

The fan brush is made from badger hair. It is a soft brush used for blending colours without leaving unwanted brushstrokes. The painter uses it to create gradations of fine lines by adding successive layers of more or less diluted colours. To control the paint, he stiffens his fan brushes by trimming them slightly with scissors.

Good-quality paintbrushes are strong and durable, provided that you take care of them. After every working session, brushes used for painting acrylic, gouache or watercolour are washed in lots of water to remove any trace of pigment, then cleaned using a mild hand soap and rinsed. Brushes used for oil painting or varnishing are cleaned in white spirit, then rubbed with a mild hand soap.

# Palettes

Left on a wood or paper palette, acrylic paint dries out in a few hours. To keep his colours moist, Christophe Drochon uses a plastic box with an airtight lid. He places two or three sheets of dampened absorbent kitchen paper (paper towel) at the bottom of this box, and he puts the lid on the box when he finishes work. This keeps the acrylic paints fresh between working sessions, over a period of several days.

For oil paint, the artist uses a traditional oiled mahogany palette. He covers it with a very fine film of acetate, with a sheet of white paper underneath. This very simple procedure does away with the need to clean the palette after every working session – plus the colours of the oil paints are clearer against a light background.

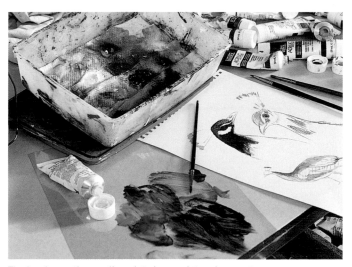

The box keeps the acrylic paints in a moist environment.
The paints are mixed on a sheet of Rhodoid (cellulose acetate).

# Composition

The main purpose of the art of composition is to make the drawn or painted image easier to read. A picture's success depends on the balance of its forms, colours and volumes. While the artist takes his inspiration from nature, he can move away from it in order to communicate his own view of reality, and to share his emotions and feelings with the viewer. Christophe Drochon's paintings have an expressive power that owes much of their immediacy to their format and composition.

From his sketchbooks, drawings or photos, the artist makes several sketches of the animal he is going to paint. As he does this he decides on a composition that will enable him to convey his idea through his painting. It is through the focus of his composition

that he imposes his own vision of the world. A rapid overview of the history of painting shows the extent to which the possibilities of composition vary, although they often remain close to a natural viewpoint. Since the 20th century however, cinema, television and photography have shown us that a close-up view gives a more striking and direct image. It is this viewpoint, sometimes carried to an extreme, that Christophe Drochon frequently adopts in his painting.

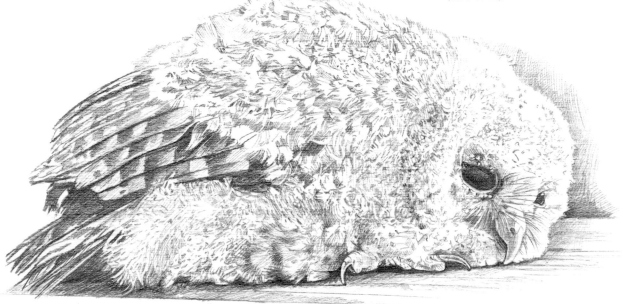

■ **Tawny owl**. Before starting a painting, the artist studies various poses of a very young owl through a series of drawings. He will choose the most expressive posture to express the bird's fragility and softness.

Conté pierre noire on paper, 14 x 13 cm (5½ x 5¼ in).

Conté pierre noire on paper, 12 x 24 cm (4¾ x 9½ in).

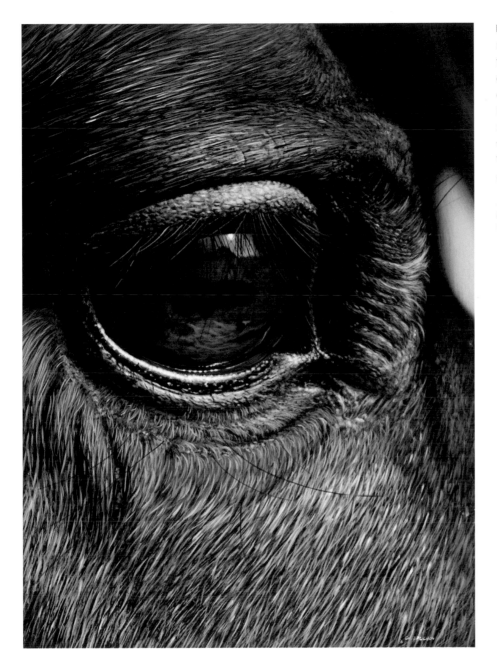

■ **Horse's eye**. The haughty gaze of this magnificent Anglo-Arab stallion, fixed on the horizon, seems to be attentive to a distant sound or movement. The shining eye is an intense black, yet it reflects the landscape that surrounds it, in an almost metallic glint that mysteriously draws the viewer's attention.
With this very close-up view, the artist emphasizes the animal's power.

*Saïd's eye,*
acrylic on illustration board, 27 x 37 cm
(10¾ x 14½ in).

# Close-up

The close-up homes in on the characteristic feature of the subject, which occupies the whole area of the picture. This enables us to appreciate its texture, form or substance. The very near close-up accentuates these effects. Christophe Drochon likes to use this type of composition to capture the gaze of an animal. Penetrating this gaze himself, he projects himself into it and conveys on the canvas an extraordinary encounter that he wishes the viewer to share.

The subject's presence and its intensity depend directly on the format of the picture. The larger the format, the more powerful the impact. In order to give prominence to the eye of an animal, the artist usually uses formats that are almost square, for front views (Master of Mysteries, page 95). Painted on a large canvas, the eyes of a big cat viewed face-on are particularly impressive. The eye, greatly magnified, appears closer and even more bewitching. If the eye is the mirror of the soul, there is no doubt that the animals of Christophe Drochon possess souls...

# Paint

C hristophe Drochon attaches great importance to the sensory perception he experiences in front of the subject he is painting. The colour of the pigments, the smoothness of the media, the brilliance of the varnishes are among the elements that guide his choices depending on what he is aiming to achieve. Each technique – oil, acrylic or gouache painting – has a different sensitivity that the artist chooses according to his project.

## Acrylic

From the second half of the 20th century, artists experimented increasingly with acrylic paint. The colours are made by mixing pigments with polymer resins used as binding agents. Acrylic paint does not undergo chemical changes; it is a stable emulsion that does not turn yellow or harden over time. It is quick-drying, which is a great advantage, especially when applying layers of colours. But this quality demands a certain skill on the part of the artist. There is very little time for hesitation; acrylic paint quickly loses its malleability and leaves no room for reworking. If you make a mistake, the only solution is to cover the wrong colour with another. Acrylic colours are applied in washes, glazes or impasto.

Acrylic paint is used straight from the tube, diluted with water or thickened using a suitable medium. Its consistency depends entirely on the artist. With added water as a wash, it spreads like watercolour; thickly applied like an oil, it allows textured or glazed effects to be produced.

Acrylic is a thin paint. Corresponding to the basic rule that paint is applied *fat on thin*, artists use it to create grounds that will then receive the subject painted in oil. This helps prevent the oil from penetrating the canvas and damaging it.

■ **Collared doves**. To paint this pair of collared doves, the painter has chosen to create a soft peaceful ambience with no strong light source and a blurred background of vegetation. The delicate shades of bluish or pinkish grey create a gentle harmony. Symbols of faithful love, the birds meet across a young shoot that is sprouting on their branch.

*Forever*, acrylic on fibreboard, 22 x 53 cm (8¾ x 21 in).

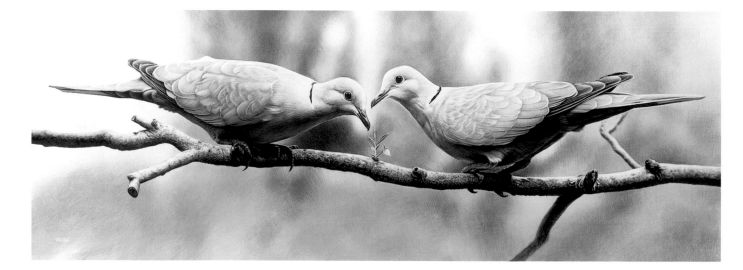

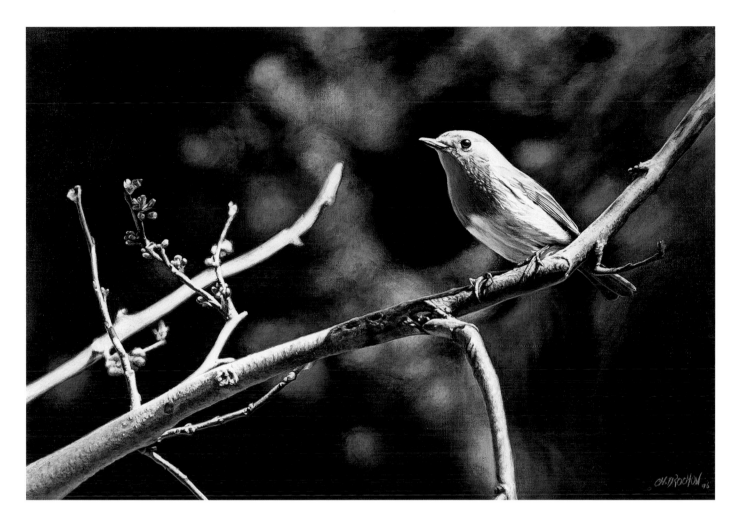

Whatever support he is using (canvas, fibreboard or illustration board), Christophe Drochon usually begins by applying a layer of very dark acrylic colours: for example, the *Polar Bear* on page 96 is painted on a black background of mars black and the *Snowy Owl* on page 120 on a mixture composed of phthalo blue, burnt sienna and hooker's green with a touch of purple violet. The dark layer must be smooth, as fine as possible, and dry. The artist then paints in acrylic or oil depending on the final effect he is aiming for.

In the case of pictures painted entirely in acrylic, Christophe Drochon uses *gel medium*, which enables him to spread the paint or make it more transparent when applying glazes at the end of the work. The effect is to unify the paint. To obtain chiaroscuro and contrasting effects, he first applies mid tones, then increasingly lighter ones. The colour of the ground supports the upper layers. Through these layers of opaque or transparent pigments, the artist achieves the effect of making the subject stand out from the background in what is often a theatrical effect.

■ **Robin**. The very dense background brings out the jaunty character of this charming robin. Application of acrylic paint in fine layers has enabled the artist to produce a true and realistic image. The reddish shades of the bird's breast and the delicate shades of its feathers are finely reproduced.

*Robin on a Judas Tree,*
acrylic on canvas, 38 x 55 cm (15 x 21¾ in).

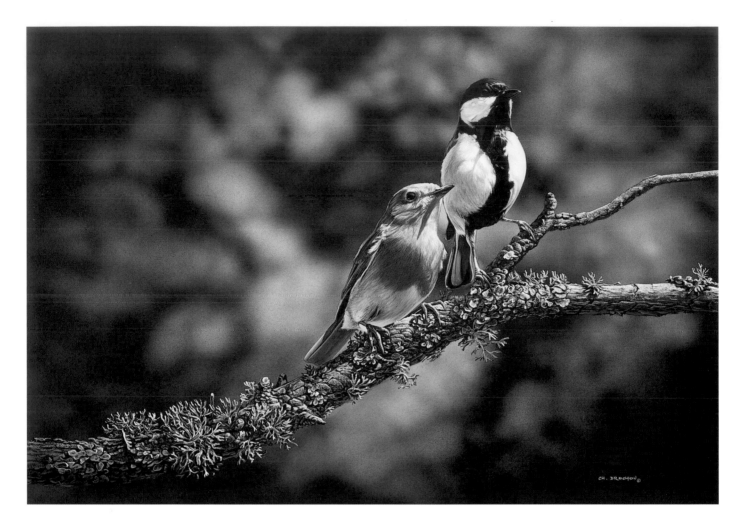

**Robin and Great Tit**. These two birds would never share the same branch in real life, but the artist has allowed himself some poetic licence...

Gouache is applied in layers. On top of washes of the main colours, the painter adds several layers of each colour, from darkest to lightest. The paint is used fairly dry, applied with the tip of the brush in order to depict the delicacy of the fine lightweight feathers of each bird. The lichen-covered branch stands out from the deliberately blurred background of greenery.

*The Impossible Pair*
Gouache on paper, 32 x 45 cm (12¾ x 17¾ in).

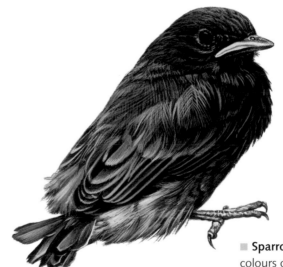

**Sparrow**. The fine texture and bright colours of gouache make it an ideal paint for depicting the glowing plumage of this familiar little bird with just a few stokes of the brush.

Gouache on paper, 8 x 7.5 cm (3¼ x 3 in).

26

# Gouache

Like watercolour, gouache is made from pigments mixed with gum arabic, tragacanth or dextrin. To thicken it and make it more flexible, manufacturers add glycerine or honey. Pigments that are too transparent are thickened with barium sulphate. Gouache is opaque and fluid and covers well.

The fineness of line that can be achieved with gouache makes it very pleasant to use. It also makes it possible to produce bright areas of flat colour. The artist uses gouache for small paintings, on paper or on illustration board. It is an ideal paint for rendering the details of a sparrow's plumage or the fur of a small rodent. It is easy to work with, even once it has dried, if you take care not to apply it in layers that are too thick. Once it is dry, gouache has a smooth and matt finish that highlights the purity and brightness of its colours. There is no need to varnish it, and indeed this would be counter-productive.

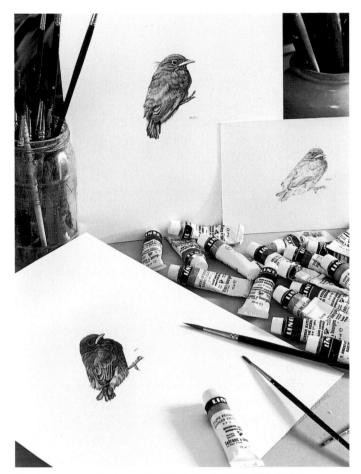

Easy to work, gouache is excellent for producing beautiful shades.

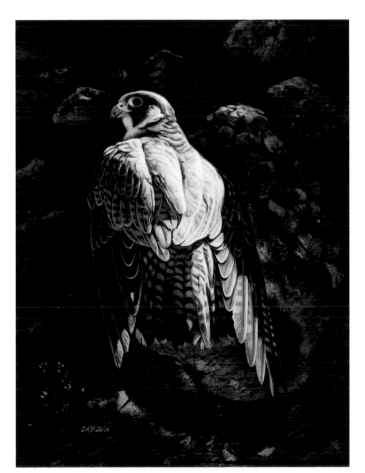

■ **Peregrine falcon.** This diurnal bird of prey has strong forms. Its wings are long and pointed, its bill short and hooked. The use of gouache has enabled the painter to graduate the colours and emphasize the contrasts, portraying this bird in a striking fashion.

*Peregrine Falcon,* gouache on paper, 17 x 12 cm (6¾ x 4¾ in).

# Oils

Oil paints are prepared by grinding pigments into powder with linseed oil, which is a sufficiently siccative oil. The resulting paint is smooth and thick, but also fairly viscous, so brush or knife marks remain visible. Each pigment requires a different proportion of oil to achieve the desired consistency, as the degree of absorption of the oil varies considerably between pigments. Manufacturers take these parameters into account in producing their oil paints to make colours of the same consistency, which are compatible and take from two to fourteen days to dry.

Christophe Drochon paints slowly, allowing the colours time to dry (see box). This way he can add layers of opaque or transparent colours without them blending with one another. Subtle shades appear through the glazes. On a dark ground painted in acrylic, he begins to apply broken colours, which he gradually thins. Even when he is painting a bird with white feathers, such as the snowy owl on page 120 or the white peacock on page 106, he applies ochre or bluish tints that serve as undercoats, then adds layers, working towards the lightest colours.

Christophe Drochon dilutes the oil paint with a painting medium, a simple mixture of siccative vegetable oil and slow-evaporating solvents, which improves the fluidity and stability of the layers of colour and removes the brush marks. When reworking dry areas, he uses a retouching varnish based on synthetic resin. This varnish promotes the cohesion of the different layers of paint. He can correct dull parts of a painting, especially where these result from the absorption of the oil by underlying layers.

The artist carefully sets out his essential tools: medium, turpentine, artists' oil paints, brushes.

## Oil paint drying times

- **Quick-drying** (around two days):
  aureolin (cobalt yellow), manganese violet, cobalt blue, cerulean blue, prussian blue, raw sienna, raw umber, burnt umber.

- **Medium-drying** (around five days):
  phthalo blue and green, burnt sienna, chromium oxide yellow and green, manganese blue, black iron oxide, cadmium red, titanium and zinc whites, carbon black, ivory black.

- **Slow-drying** (over five days):
  sunset yellow, permanent red, alizarin crimson, madder lake, quinacridone violet.

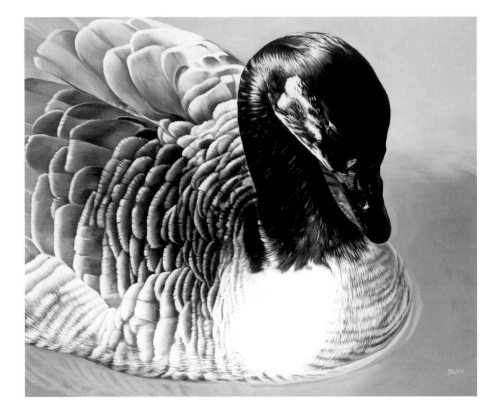

**Canada Goose**.
With its head lowered, the goose glides silently over the green water of the pond. The smooth oil paint has enabled the painter to convey the shine of the dark-blue feathers of the head. The wing feathers stand out clearly from one another giving the animal volume.

*Melancholy*, oil on canvas, 81 x 100 cm (32 x 39½ in).

**Polar bear**. Under the effect of the late-afternoon sun, the reflection of a rock in the water is transformed into gold. The swimming white bear breaks through this mirrored surface, creating behind it a rippling blue-tinged wake. The oil colours recreate this shimmering world.

*Polar Bear Swimming*, oil on canvas, 65 x 92 cm (25¾ x 36¼ in).

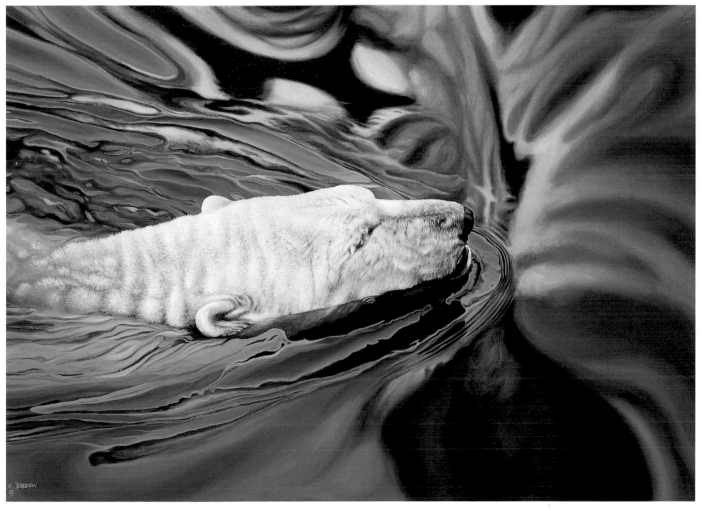

# Glazes

The role of glazes is to create effects of transparency that accentuate the depth of a composition. They can strengthen its tonality or produce a new colour. Glazes are usually used in the final stage of the painting process. The technique consists of applying a layer of colour diluted in a special very clear medium on top of an opaque colour. Christophe Drochon uses glazes during the various stages of his work, which enables him to achieve particularly interesting transparent effects. This work demands a great deal of care, as the glaze has to be applied onto a thin dry layer. When he has finished the painting, the artist applies a final glaze that enables him to harmonize the tonality of the painting, whether warm or cold.

## Application of the glaze

The paint is mixed with the medium to obtain a smooth consistency then finely spread over the layer of dry paint with a broad soft-haired brush. The glaze has to be left for a few minutes to allow the thinner it contains to evaporate. The artist uses a flat "cat's tongue" brush with a rounded tip for the smallest areas. If part of the glaze has to be removed, he wipes it with a piece of cloth moistened with turpentine.

The application of layers of glaze creates a sense of volume.

---

**Transparent colours for glazes**

- **Reds:** quinacridone red, carmine, alizarin crimson
- **Yellows:** sunset yellow, raw sienna, transparent gold ochre, cobalt yellow
- **Blues:** phthalo blue, ultramarine, cobalt blue
- **Greens:** phthalo green, viridian, terre verte (green earth)
- **Violet:** quinacridone violet
- **Browns:** burnt umber, burnt sienna
- **Black:** ivory black

# Finish varnishes

Christophe Drochon finishes his paintings with an application of gloss varnish. He prefers the effect this produces to that of satin or matt varnish. The pure gloss varnish he uses is composed of synthetic resins diluted in petroleum essence. This fluid finish can be worked easily for long enough to cover a large area. The artist uses the same varnish regardless of the medium he is working in – oils or acrylic. He likes its glossy appearance, which fades gradually over time.

The artist ensures that the painting he is going to varnish is completely dry. He sometimes has to wait several months, even a year, before varnishing. To prevent dust settling on it, he works in an insulated draught-free room. The atmosphere of the room is pleasantly warm and not humid. He lays the painting flat on a table and against the light to enable him to spot any unvarnished areas.

## Applying the varnish

Before beginning, he cleans the surface with a damp sponge. He rinses a soft silky ox-hair graining brush in water. He dries it with a hairdryer, then pours the pure varnish into the centre of the canvas. He spreads it gently towards the edges with the graining brush. Then he works over the surface from top to bottom, without applying pressure. The brush is tilted and leaves no mark. Varnishing has to be done quickly, before the varnish begins to get sticky. The varnish dries to dustproof in a few minutes, but it takes several weeks for the gloss film to be fully dry.

The finish varnish is spread in both directions over the dry painting with the graining brush.

# Sketches

# Red-legged partridge

Although it is common to see partridges running and fluttering about in the countryside, at the forest edge, it is practically impossible to get close to them. It is only really possible to observe them at close quarters and do sketches and drawings at a specialist poultry breeder's. The red-legged partridge has grey plumage sprinkled with tinges of various shimmering reddish-browns. Its white throat is surrounded by a blue-black collar broken up into markings pointing downwards. The bill and area around the eye are red, as are its tarsi.

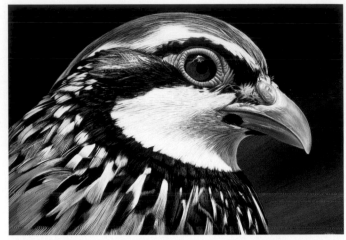

*Red-legged partridge*, acrylic on illustration board, 39 x 54 cm (15½ x 21¼ in). The longest feathers are painted with hatching in contrasting colours.

## materials

- 125 gsm fine-grained white drawing paper (format: 24 x 32 cm/15½ x 12¾ in)
- HB, 2B pencils or graphite leads
- Propelling (mechanical) pencil
- Conté pierre noire, HB leads, 5 and 6 mm (¼ in) diameter
- Stanley (X-Acto) knife and sandpaper for sharpening the leads
- Fixative

**1 The first graphite lines** mark out the contours of the bird's head and breast. The eye is positioned behind the prominent rounded bill.

**2 The darkest shades** encircle the eye and extend into a collar around the bird's neck. The top of the skull is emphasized with a grey-tinted tone.

**3** Small oblong grey marks around the breast indicate the feathers. Layers of short heavy lines allow the volume of the partridge's body to be built up.

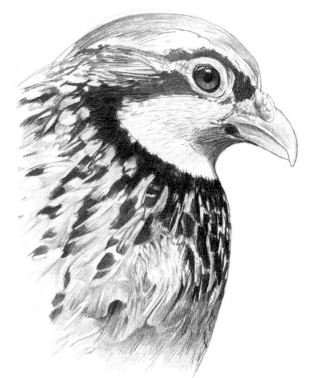

**4** The thick hooked beak is lit vertically. Fine grey hatching darkens the mandible and throat, which are in shadow. Progressive work over all the plumage balances the shading.

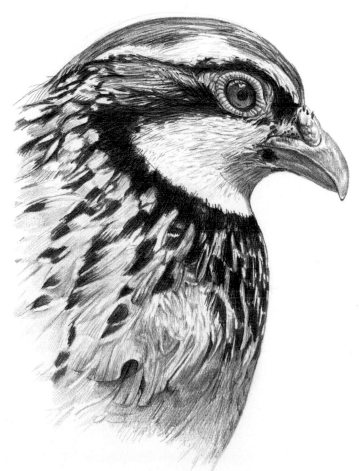

**5** The darkest areas are accentuated with further application of black graphite. The eyelid around the eye is made clear with the point of the pencil. Sparkles of light where the paper is left white over the pupil add expression to the partridge's eye.

# Red-legged partridge, three-quarters view

**The partridge's silhouette** is outlined, then an opaque black background is added behind the head to bring out the intensity of the light and to emphasise the direction of the bird's gaze.

**The round eye** surrounded by a thin black line is drawn on the side of the head, behind the bill. A black band descends from the eye to the collar, which is expanded. The bird's neck and throat are covered in more or less close hatching to mark the shadows.

**Work continues** by modelling the shapes. This is done by applying various shades of grey to the wing and along the body and abdomen of the partridge. The volume becomes clear with additional shading and heavier drawing of the feathers.

A **few final pencil marks** are necessary beneath the abdomen, on the tarsi and body to strengthen the shadows and create balance in the whole composition. The finished drawing is protected with a spray of fixative.

Conté pierre noire on paper, 21 x 18.5 cm (8¼ x 7¼ in).

**Chukar partridge**. Related to the mountain rock partridge, the Chukar partridge was introduced into France as a restocking game bird. It is less brightly coloured than the red-legged partridge. Its cream-coloured throat is bordered by an intense black collar, which descends to the breast. The rest of the plumage is not chequered, but consists instead of a tangle of white, grey and black feathers on a slightly honey-coloured background. Conté pierre noire is used to render these greyish shades perfectly. The head stands out from the opaque background. The eye is accentuated by the deep black shading around it.

Conté pierre noire on paper, 18 x 20 cm (7 x 8 in).

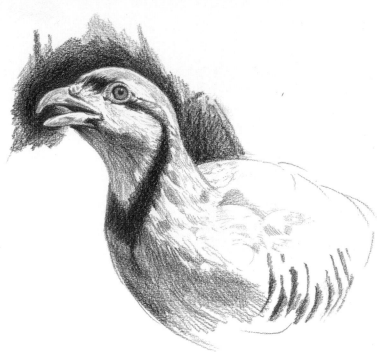

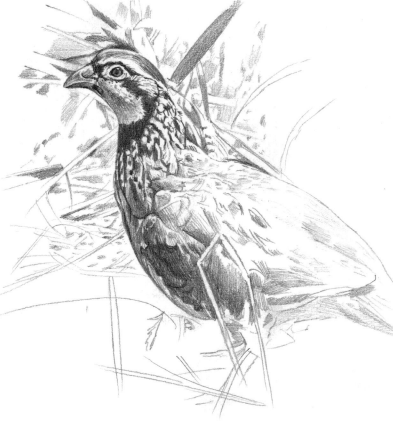

**Red-legged partridge in the wheatfields**. In its natural environment, this red-legged partridge shows off all the characteristic features of its species: an intense black collar and colourful breast with large russet, brown and white feathers. The plumage on the body is treated in broad areas with varying shades of grey. The wing and tail are suggested with a contour line. The legs are roughly sketched among the wheat ears. The resulting drawing is lively and dynamic.

Conté pierre noire on paper, 16 x 7 cm (6¼ x 2¾ in).

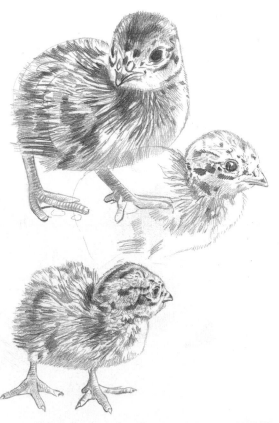

**Young chicks**. These little three-day-old red-legged partridges resemble little balls of ochre-coloured down, with a few darker feather edges. Whatever the posture of the chick the outline of its contour, always a basic oval shape, differs little. Small graphite pencil lines follow the direction of the emerging feathers. Some closer hatching accentuates the shading. A point lights up the eye; two lines suggest the beak. The chicks look full of life.

Conté pierre noire on paper, 21 x 14 cm (8¼ x 5½ in).

# Capturing the gaze

The eyes of animals express their state of mind. The artist tries to capture the fear, contentment or melancholy that is in their gaze and convey this in his drawings and paintings.

The eye is a sphere set in a socket. On its slightly convex façade, you can make out the colourful iris and the very dark pupil, which carries the gaze. In mammals the large iris is often ochre or light brown, with golden and sometimes bluish glints. The black pupil occupies an important place in the centre. In birds, the shape of the eye is usually rounder, the eyelids barely visible, and the iris is a strong bright colour (yellow, orange or red).

The surface of the eye lies within two circles: the outer circle of the iris with the pupil in its centre. A third small circle conveys the point of light. This is positioned on the edge of the pupil in a place that varies according to the orientation of the light source. It is this glimmer of light that gives the gaze its particular expression.

## The wolf's eye in pencil

HB Conté pierre noire on 180 gsm grained paper, 19 x 24 cm (7½ x 9½ in).

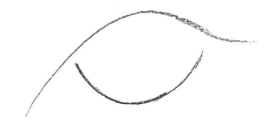

1 **Outline of upper eyelid** and lower edge of the eye; it is elongated into an almond shape.

2 **Positioning of the circles** that form the eye and of the point of light at the top of the pupil.

3 **The pupil and edges of the eyelids** are darkened. The artist uses cross hatching to produce graduated shading.

4 **Detail of the eyelids around the eye**; these are the darkest areas. The point of light is left blank. The wolf's fur is indicated by a little hatching around the eye.

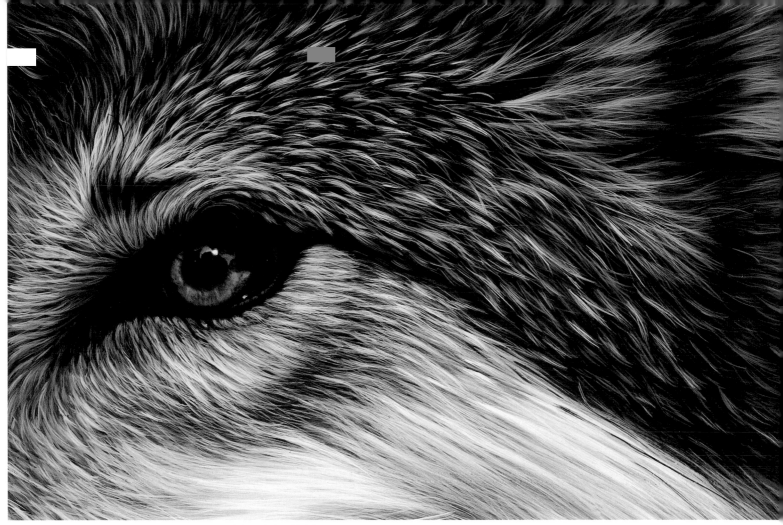

*The wolf's gaze,* acrylic on illustration board, 25 x 30 cm (10 x 12 in).

■ **Female grey wolf**. The close-up composition accentuates the wolf's soft gaze. The fur is depicted with successive layers of small brushstrokes of grey, russet and tawny, showing the direction the fur lies in. Brushstrokes of almost pure white are mingled with the lightest lines.

# The wolf's eye in acrylic
Acrylic on 300 gsm watercolour paper, 19 x 24 cm (7½ x 9½ in).

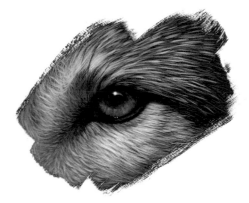

**1** **A dark blue point** is positioned in the centre of the black background. It marks the position of the light around which the eye is going to be composed.

**2** **The area around the eye** and the pupil are left black. The artist shapes the contours with small fine lines using the tip of a paintbrush. Yellow ochre tones light up the iris.

**3** **The fur takes on volume**. The bluish lines, getting gradually lighter, show the way the fur lies. The eye ringed with black appears to sink inwards slightly; the eye gleams.

# Tiger

Oil pastel sticks are made from pigments bonded in a mixture of wax and oil. This is an easy-to-use medium that covers well and adheres to all supports. The effect is sumptuous, the colours dazzling. This technique is ideal for producing an accurate portrait of this tiger. Using sketches from life, the work is built up progressively. Only an overall vision enables the artist to capture the balance between the dark and light areas.

**1** **The pencil drawing** is very detailed. A fine line marks out the contours of the skull, the volume of the cheeks, the shape of the ears and the downward curve of the muzzle. The eyes are positioned on a mid line in the centre of the head. The stripes and markings of the animal's coat are drawn accurately to help with the colouring.

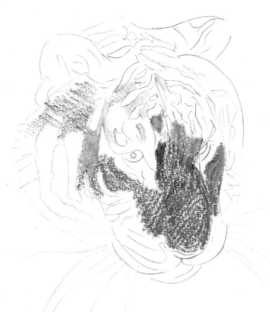

**2** **The first marks in oil pastel** are applied in hatched lines to suggest the appearance of the fur. The tones are warm: yellow ochre and brown.

## materials

- 200 gsm fine-grained white watercolour paper (format: 24 x 32 cm/9½ x 12¾ in)
- HB graphite pencil
- Oil pastels: white, sky blue, cyan, ultramarine blue, prussian blue, flesh, olive brown, yellow ochre, red ochre, burnt sienna, black, grey, orange.
- Small scalpel blade
- Fixative spray

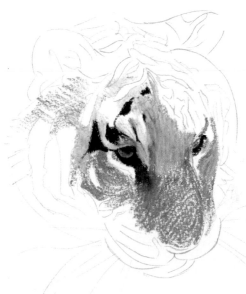

**3** **The eye is drawn** with the tip of a grey-blue pastel and surrounded with black. It is important to establish where the animal is looking to bring it to "life".

**4 Fine hatching** with a more or less intense shade of ochre suggests the volume of the head. Bluish shades on the hairs of the cheeks give an overall sense of depth.

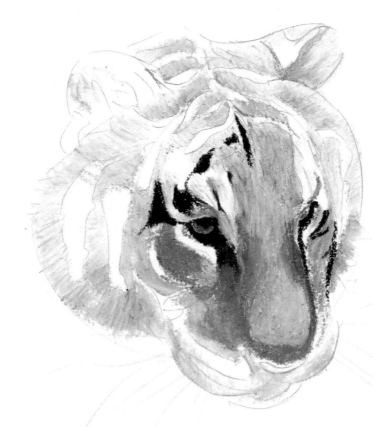

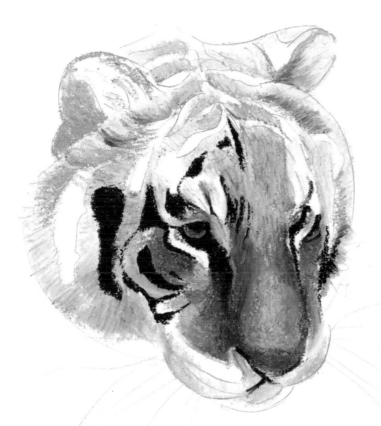

**5 More or less intense** browns and blacks follow the outline of the stripes and markings, to accentuate their three-dimensional quality. A line of black pastel marks out the contour of the muzzle and the ears.

**6 The shadows are reinforced** with dark blue and black tones on the cheek, brown, ochre and red on the muzzle and on the top of the head. Heavy and dense lines of pastel produce the desired realism. They follow the direction of growth of the fur. Several successive layers of oil pastels are required to build up the colours while keeping some areas of transparency.

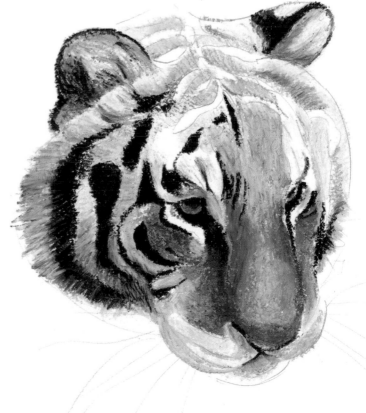

7 **Blue-grey shadows** completely surround the cheeks and chin, and fill the tiger's ears. On this halo-like background, the head, lit from above, stands out clearly in relief. Touches of white pastel provide glimmers of light around the eyes and highlight the cat's cold gaze. At this stage, the pastel can be lightly fixed.

8 **The shadows around the muzzle and beneath the chin** are emphasized with brown and dark blue tones and touches of black. The whiskers are drawn carefully with the point of the scalpel, which enables a bit of pastel to be delicately removed. They are extended by a few fine grey and blue lines. This gives the picture a certain lightness. The drawing is completed with three applications of fixative, allowing it to dry fully between each application.

■ **Tiger lying down**. The artist drew this adult tiger from life using Conté pierre noire. The stripes on the body and legs follow the shape of the muscles.

Conté pierre noire on paper, 12 x 22 cm (4¾ x 8¾ in).

■ **Study of the head**. This tigress, just a few months old, still has long fur, down in her ears and a mischievous look in her eye. The black background highlights the brightness of her fur. The contours are achieved by meticulous work in short light-grey and mid-grey lines. Black hatching marks the location of the stripes.

Conté pierre noire on paper, 15 x 19 cm (6 x 7½ in).

■ **Tiger in profile**. The play of light on the shoulder and haunch emphasizes the power of the animal's muscles. With his head stretching forwards, he adopts a watchful attitude.

Conté pierre noire on paper, 14 x 21 cm (5½ x 8¾ in).

# Painting fur

Animal coats come in a wide variety of textures, from the very short smooth fur of the stag or spotted fur of the big cat to the dense fur of the bear. In all cases, the painter's work begins with the application of dark grounds or layers of washes to obtain the dominant colour. On these dry grounds, short fine lines of stripes or spots can be drawn with the tip of a fine paintbrush, following the direction of the fur's growth. To depict the head of this leopard, Christophe Drochon chose a mixed-media technique: Conté pierre noire and acrylic. This animal has short glossy fur, orangey ochre in colour. Its coat is covered with a multitude of small black markings, arranged in groups of three, four or, more often, five. The painter has deliberately spent a lot of time on the creases of the neck and on the down of the ears.

## Study of a leopard
Acrylic on 300 gsm watercolour paper, 24 x 32 cm (9½ x 12¾ in).

**2** **The most interesting area** to work on is around the neck. The painter applies dark tints (mars black, burnt sienna), which he lightens towards the cheek (raw sienna).

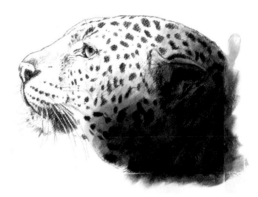

**3** **The inside of the ear** and the top of the skull are painted in the same shades, with the addition of a tinge of mars yellow. The first black markings are painted.

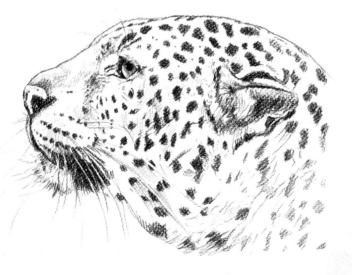

**1** **Two strips of adhesive tape** are placed at right angles along the bottom and side to frame the drawing. The artist outlines the contour of the head and draws the muzzle, eye and ear. He marks out the shading with fine, more or less dense, hatching. The black markings on the animal's coat are marked less heavily on the neck.

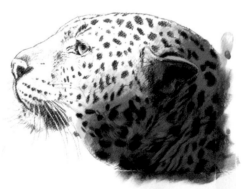

**4** **In the foreground**, the dark shapes (a mixture of raw sienna, red, light purple violet and black) are marked out with a flat brush. On the cheek and the back of the skull, the colours are lighter and tend towards orangey yellow. A flash of light is applied to the top of the ear.

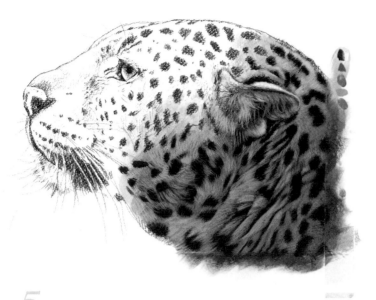

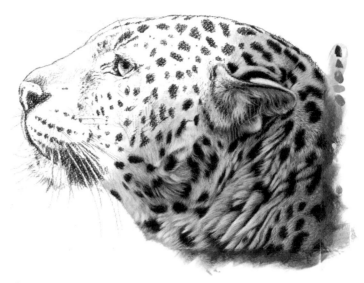

**5** **The work continues**, taking care to follow the direction the hairs lie in. Supple and rippling, the fur forms into creases that give the appearance of depth. Christophe Drochon applies light colours onto the dark ground.

**6** **The colours applied** are increasingly pale; the contrasts are made increasingly forceful. Each tuft of hair stands out clearly. Russet tints predominate at the back of the head.

**7** **A very light glaze of mars yellow** over the whole painting warms the colour. The whiskers are indicated by long flowing white lines. The artist applies an oil varnish over his composition and removes the tape surrounding it.

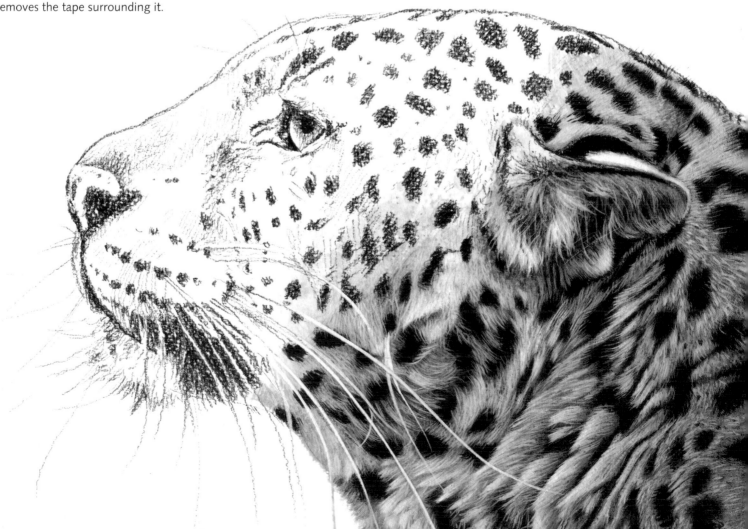

# Female grey wolf

Originating in Poland, this female grey wolf does not live in the wild, but in the park of a wildlife enthusiast where the artist has been able to observe her at length. This beautiful still-wild animal answers to the name of Siska. Her direct open gaze is fascinating. Before painting the portrait shown here, lots of sketches were necessary to capture the wolf's personality. This study in Conté pierre noire shows her at peace with the world, with no trace of aggression.

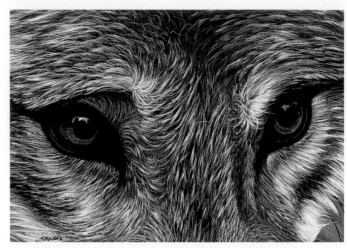

*Female grey wolf, face on*, gouache on illustration board, 25 x 30 cm (10 x 12 in). The close-up composition intensifies the wolf's gaze.

## materials

- 200 gsm fine-grained white watercolour paper (format: 24 x 32 cm/9½ x 12¾ in)
- H, HB, B and 3B Conté pierre noire; pencil or lead 5 and 6 mm (¼ in) in diameter
- propelling (mechanical) pencil
- Stanley (X-Acto) knife
- fine sandpaper
- fixative

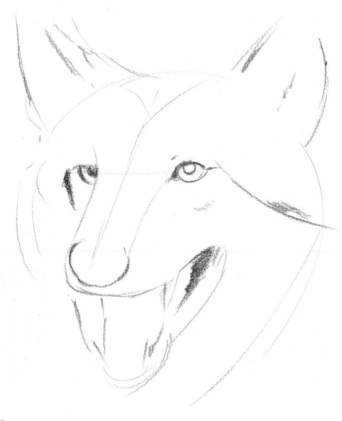

**1** **An oblique line** passing through the centre of the muzzle indicates the angle of the head. A horizontal line positions the eyes.

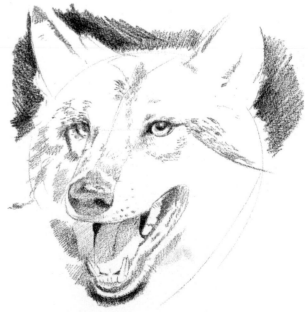

**2** **A light line** of well-sharpened Conté pierre noire defines the contours of the head. The eyes are drawn with precision. A shadow in the open mouth gives a sense of its depth.

**3** **Close dark hatching** surrounds the top of the skull. This very dense black background highlights the subject, which seems to literally stand out from the page. Shadows are positioned along the muzzle and around the eyes, following the animal's bone structure to convey its three-dimensional form. The pricked-up ears suggest an attentive and cheerful demeanour.

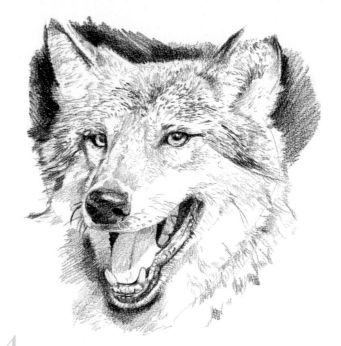

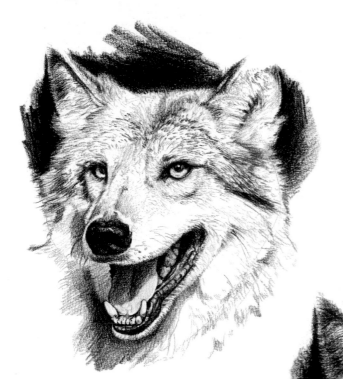

**4** **The wolf's fur** is drawn with fine hatching. Lines of Conté pierre noire follow the lie of the hairs, on either side of the mid-line of the muzzle. Application of some lighter greys gives the coat thickness. The very black nose is lit up by a very narrow patch of light. The lower lip, the jaws and the teeth are drawn with precision.

**5** **The dark background** is reinforced to bring the subject forward. The shadows of the mouth are accentuated. The darker area around the eyes brings out the acuity of the animal's gaze. Narrow areas of white give the lips shine. The drawing is protected with two or three light sprays of fixative.

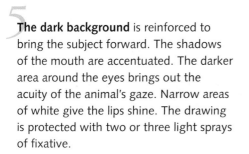

47

Like a musician practising his scales, the artist does lots of sketches to commit to memory the postures of Siska that he feels are most characteristic. From these he will make paintings in acrylic, in which the animal will appear in all her splendour. The fur absorbs light differently according to the pose.

■ **Throwing back her head**, the wolf howls to communicate with the pack. The pale shades of her chest are shown in full light.

■ **Face on**. This view shows Siska with her ears pricked up and her mouth slightly open in an anxious, expectant look.

Conté pierre noire on paper, 27 x 37 cm (10¾ x 14½ in).

■ **The long tufts** of the winter coat of the animal at rest and observed from the side, begin to stand out on her side and haunch.

■ **The profile of the head** clearly shows the characteristics of the species: short ears turned backwards, elongated skull, almond-shaped eye and a close set of teeth with long pointed canines.

■ **Sometimes an eye is enough to convey an expression**. The fineness of the black ring around the eye, the lower rim and the strongly hatched shadows inside the socket and on the arch of the eyebrow give depth to the wolf's melancholy gaze.

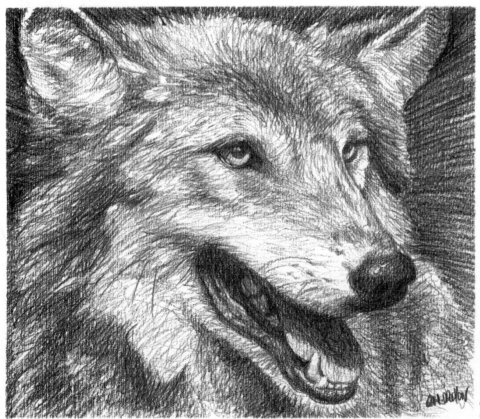

Conté pierre noire on paper, 37 x 46 cm (14½ x 18¼ in).

■ **This expression is attentive**: the animal's ears are pricked forward. Her bright luminous gaze is obtained by leaving small areas of white paper. The nose appears shiny with very black nostrils.

The fur is treated with a light touch, with small lines directed away on either side of the head.
On the body, the slight shadows express the thickness of the parti-coloured fur.

# Painting plumage

With most birds, the wing and tail feathers are smooth and stand out clearly, while those of the breast are downy and generally self-coloured. Having applied the grounds of dominant colours, the surface feathers are drawn in their respective colours with the tip of the paintbrush. Light touches alternate with small hatched lines. The finely outlined flight feathers indicate the lie of the feathers on the wing. Each well-lit feather edge is surrounded by a shadow, which gives the whole bird an impression of volume and three-dimensionality.

■ **Studies of kestrels**.
The various postures of the bird show the characteristics of the species: small round head, short hooked bill and no neck.
The very round eye of this hunting bird is at the front of the head, enabling it to follow its prey.
The short colourful top feathers are sprinkled with small spots.

Drawings in HB lead pencil on 180 gsm grained paper, 46 x 37 cm (18¼ x 14½ in).

# Study of lanner falcon

Acrylic and gouache on 300 gsm watercolour wash paper, 25 x 20 cm (10 x 8in).

**1** **The bird of prey is sketched** with pencil lead.
The first light outline of the contour is worked over with a heavier line. The bill and eye are well defined. The edges of the feathers of the half-open wing are drawn strongly.

**2** **The bird stands out** against a dark green background.
Using acrylic, the artist applies more or less dark greys to the bird's wing. The tonalities are achieved with mixtures of black, raw sienna, mars yellow and white. A few touches of ochre and blue bring a three-dimensional quality. The back and tail are worked in colours lightened with white. The falcon is standing on a branch suggested by a few brushstrokes of dark ochre and black.

**3** **The detail of the feathers** is worked in gouache.
Each of the long flight feathers is picked out with a fine paintbrush, with small delicate brushstrokes. A blue shadow stresses the roundness of the breast. A point of light in the eye suggests the bird's gaze.

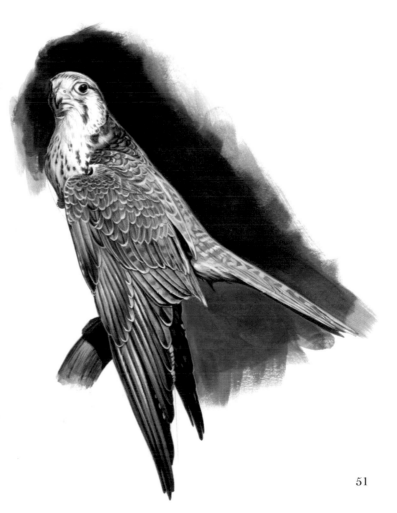

# Macaw

The blue and gold macaw comes from Central and South America. It is a magnificent parrot with a large hooked bill. It has a long colourful layered tail. This animal thrives in captivity, which enables it to be studied at very close quarters. The artist has chosen to present a back view of the macaw, with its head turned to show its electric-blue plumage in full light. The yellow note of the neck feathers adds dynamism to the whole drawing.

*Black Sun,* acrylic on canvas, 38 x 55 cm (15 x 21¾ in). This blue macaw was painted in the light of the solar eclipse of August 1999, an event reflected in the bird's eye.

## *materials*

- 200 gsm fine-grained watercolour paper, format 32 x 24 cm (12¾ x 9½ in).
- HB and 2B pencil lead
- Squirrel-hair pointed mop paintbrush
- Watercolours: ultramarine, cyan blue, light cadmium yellow, golden yellow, cadmium red

**1** **Capturing the basic shape** of the bird by first outlining its contour.

**2** **The thick distinctly hooked bill** is indicated with a heavy line. The coloured areas of the head are marked out, as well as the round eye. The drawing of the feathers begins: these are small, close to the neck and get bigger the closer they are to the tail.

3 **The addition** of an intense black background brings out the areas of strong light on the parrot's head and neck. The details of the head and the shadows between the feathers are worked over in turn with HB and 2B lead pencils.

4 **A first glaze** of diluted cyan blue watercolour is applied onto the head and body of the bird with the brush very wet. The area of the neck is given a very pale yellow tint.

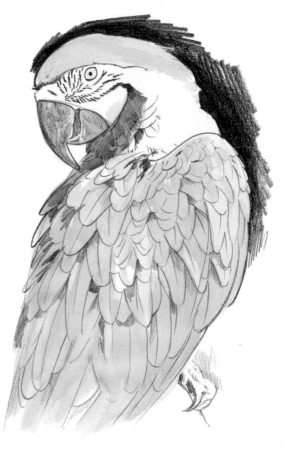

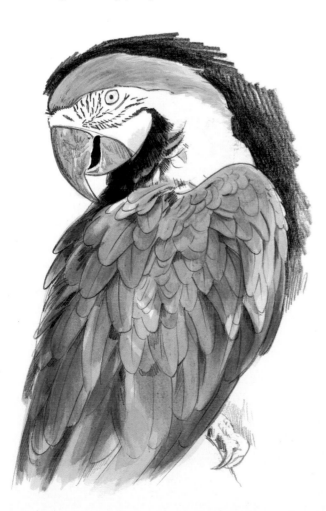

5 **The crown of the head and the feathers** are washed over with layers of ultramarine and cyan blue. The underlying pencilled areas reinforce the blue tones and create shadows that produce a sense of volume. A few lines of pencil lead bring out the details of the head and bill.

6 **The drawing of each feather** is retouched with the tip of the paintbrush loaded with cyan blue. The layers of wet colour on a dry ground accentuate the three-dimensional quality. The neck is painted with small blended brushstrokes of golden yellow and cadmium red. The bill, feathers and crown of the head and inside of the neck show greenish highlights obtained by a mixture of blue and a tinge of cadmium yellow. The painting is protected by a thin layer of fixative.

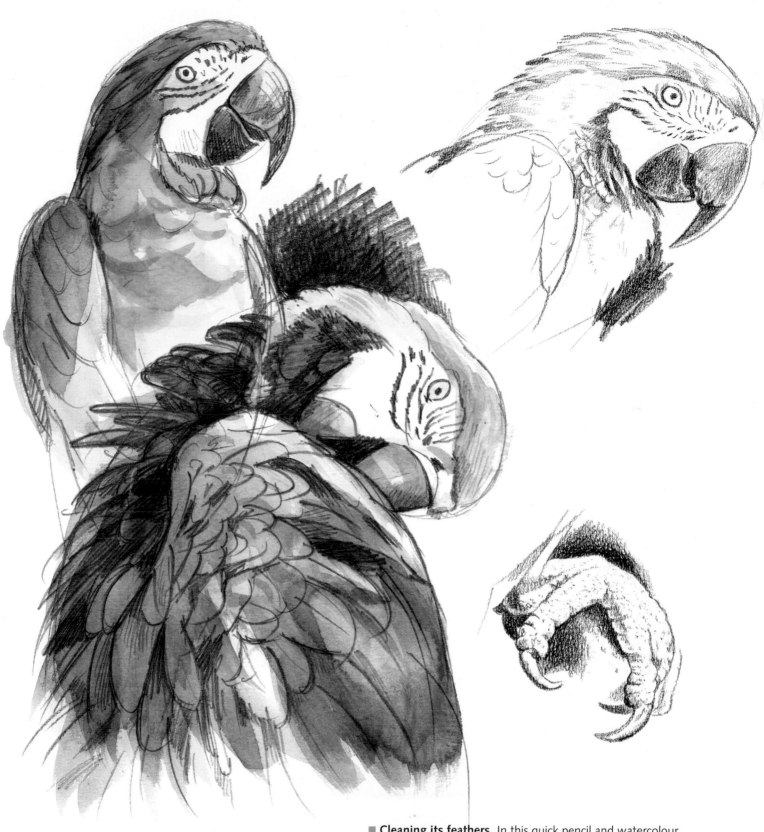

■ **Cleaning its feathers**. In this quick pencil and watercolour sketch, the artist has taken pains to show the movement of the feathers standing up as the macaw turns round. The very accurate drawing of the parrot's head at the top of the composition highlights the strength of its large hooked bill.

Watercolour and lead pencil, 25 x 16 cm (10 x 6¼ in).

# From rock to animal

Working with contrasts can take many forms. Nature offers a wide variety of subjects for painting, and some quite unexpected models can provide an opportunity to practise chiaroscuro and textural effects. Rocks, for example, come in fascinating forms. Christophe Drochon is particularly interested in those to be found in the forest of Fontainebleau, near the French village of Barbizon. Drawing these rocks is for him what practising scales is for a musician.

There are instances of astonishing similarities between a rock and an animal. The famous "elephant" rock of Barbizon has been immortalized by many painters, yet others suggest the shape of a tortoise, an eagle, a bear or a dog... Also, small blocks of stone change colour with the passage of the clouds or with the strength of the sun's rays. Shadows fill with colour, lights shimmer. The forest of Fontainebleau is an ideal place to let your imagination take flight.

■ **The elephant's head**. Not all the sedimentary layers of sandstone erode at the same rate. Fissures and outgrowths have formed these imposing shapes, which resemble the profile of an elephant and the characteristic folds of its skin. The drawing in Conté pierre noire brings out the play of dark and light created by the hollows and flat surfaces of the rock.

Conté pierre noire on paper, 21 x 18 cm (8¾ x 7 in).

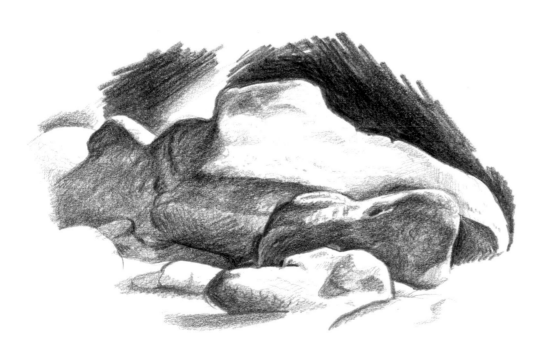

■ **Rocks**. A mass of rocks rounded by the action of time. Great blocks overlap one another, crevices disappear into shadow and tops gleam in the sun. Lit dramatically, the rock has little shadow on its gently uneven slope. The fine hatching with Conté pierre noire accentuates its three-dimensionality.

Conté pierre noire on paper, 15 x 24 cm (6 x 9½ in).

56

■ **The dog's head**. This squat rock, full of holes and fissures, shows some particularly strong contrasts. The very black background projects the mass of the large smooth areas forwards. Lit by the setting sun, they need only a little intervention on the part of an artist. The shadows in Conté pierre noire are powerful but subtle in order to bring out the expressive relief. It is easy to see the eye and half-open mouth of the dog and the beginning of its neck, worked in varying shades of grey.

Conté pierre noire on paper, 13 x 23 cm (5¼ x 9 in).

■ **The rhinoceros**. In this drawing in Conté pierre noire, Christophe Drochon has put his studies of rocks to good use. The animal's voluminous mass stands out starkly against the dark background. The rhinoceros' belly, its forelegs and its neck are worked in hatching following the contours of the muscles and folds of the skin. The shadow on the ground provides the imposing animal with a base.

Conté pierre noire on paper, 12.5 x 18 cm (5 x 7 in).

# Asian elephant

One fine summer morning, two Asian elephants, mother and daughter, stroll around in their huge enclosure at Vincennes zoo in Paris. They frolic in their pool and squirt water in all directions in the sunshine. The imposing silhouettes of these pachyderms lit from the front stand out against the rocky background. The wrinkled skin of the older elephant shows roughness, pits and bumps, and a scale of shades of grey, which make it a particularly interesting subject to draw.

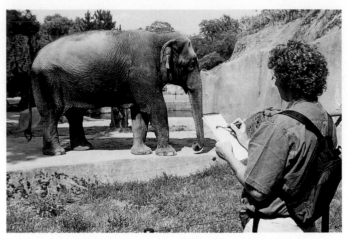

This pachyderm standing out against a background of rocks is an ideal subject for studying the effects of chiaroscuro.

## materials

- 200 gsm fine-grained white watercolour paper (format: 24 x 32 cm/9½ x 12¾ in)
- HB Conté pierre noire; pencil or leads
- Propelling (mechanical) pencil
- Stanley (X-Acto) knife
- Fine sandpaper
- Fixative

**1** **A long period of observation** enables the artist to draw the outlines of the animal in one go. He suggests the general shape of the ear and the folds of the skin with a few lighter lines.

**2** **The pachyderm is lit from the front**. The dark background is applied by rubbing the rounded end of the Conté pierre noire on the paper. Applied above, behind the head and to the right of the subject, this solid colour creates a very strong contrast that allows the brightest areas of light to be defined.
The hindquarters of the animal stand out against the white paper. A sense of volume is achieved by the addition of the first shading.

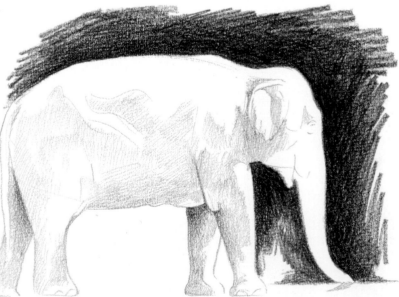

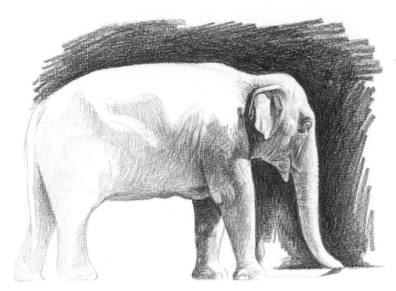

**3** **The shadows beneath the belly** and inside the forelegs are strengthened by small precise lines.
The range of greys is slightly greater on the inside of the legs and neck.
The hatching follows the details of the muscles of the head and trunk, leaving the lit areas unmarked.

**4** **Work progresses** on the shadows on the animal's body and on its hind legs with successive additions of more or less heavy lines. The Conté pierre noire is cut regularly and sharpened with sandpaper.

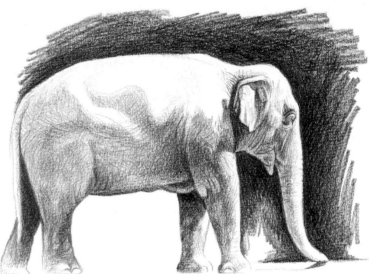

**5** **Dramatic chiaroscuro effects** highlight the texture of the pachyderm's skin. Each muscle of the animal is faithfully rendered with lines of Conté pierre noire following the rounded shapes and the movement. The drawing is finished off with three light sprays of fixative.

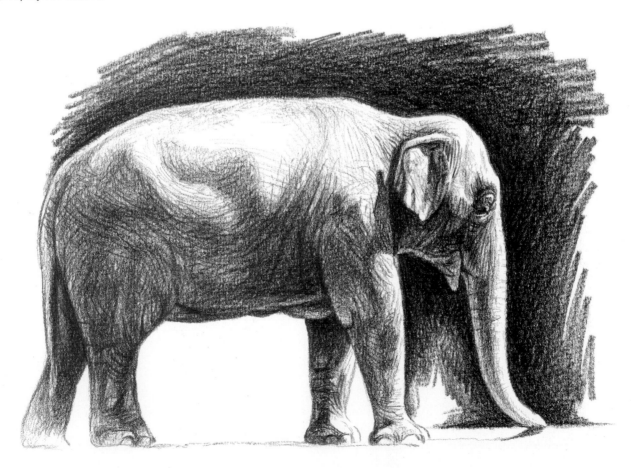

# Study of the head

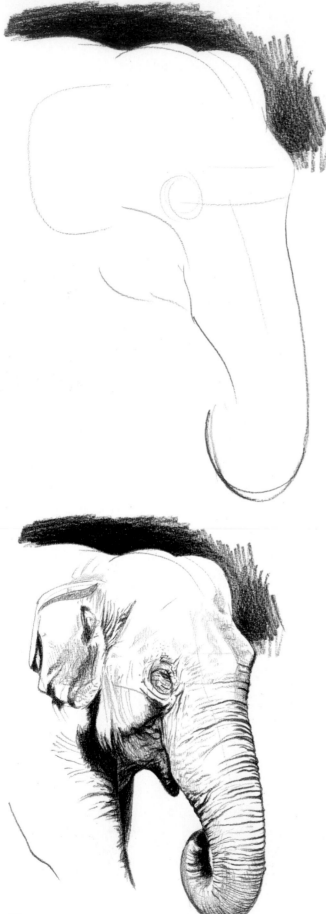

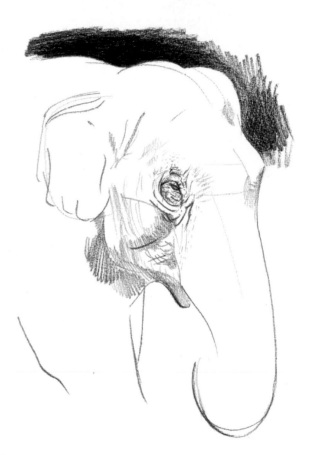

1 **Viewed at a three-quarter angle,** the head of this elephant offers a multitude of details needing meticulous treatment. A light line defines the contour of the skull. First the eye, then the ear and the cheek are put in position. The trunk is barely sketched.

2 **The flat area of black** in the background heightens the effect of the light on the head. The Asian elephant's ear, triangular in shape, is smaller than the ear of its African relative.

3 **Strong shading** is applied beneath the neck. Fine hatching brings out the hollow of the cheeks, following the shapes of the bones under the skin. The trunk is drawn in minute detail to give it volume. The horizontal lines are more or less heavy and close together, with the lit areas left blank.

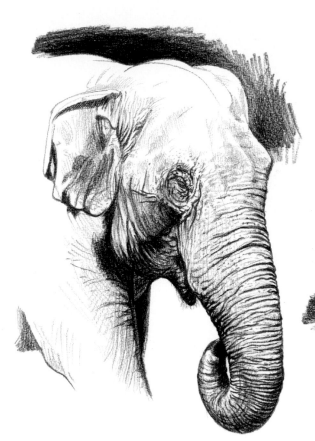

4 **To give the animal greater presence**, its leading foreleg is suggested. However, it is the head that remains the centre of interest of the drawing.

5 **Further shading in Conté pierre noire** is added, particularly to the folds of the trunk, the shadows of the ear, the neck and the lip, giving the whole drawing depth and realism. Conté pierre noire is very responsive to the movements of the hand. Cut into a bevel shape, it allows the artist a scale of shades to choose from. Close hatching follows the curves of the folds of the elephant's skin. The smooth line it produces is very dynamic and useful for creating strong contrasts.

Conté pierre noire on 200 gsm watercolour paper, 32 x 24 cm (12¾ x 9½ in).

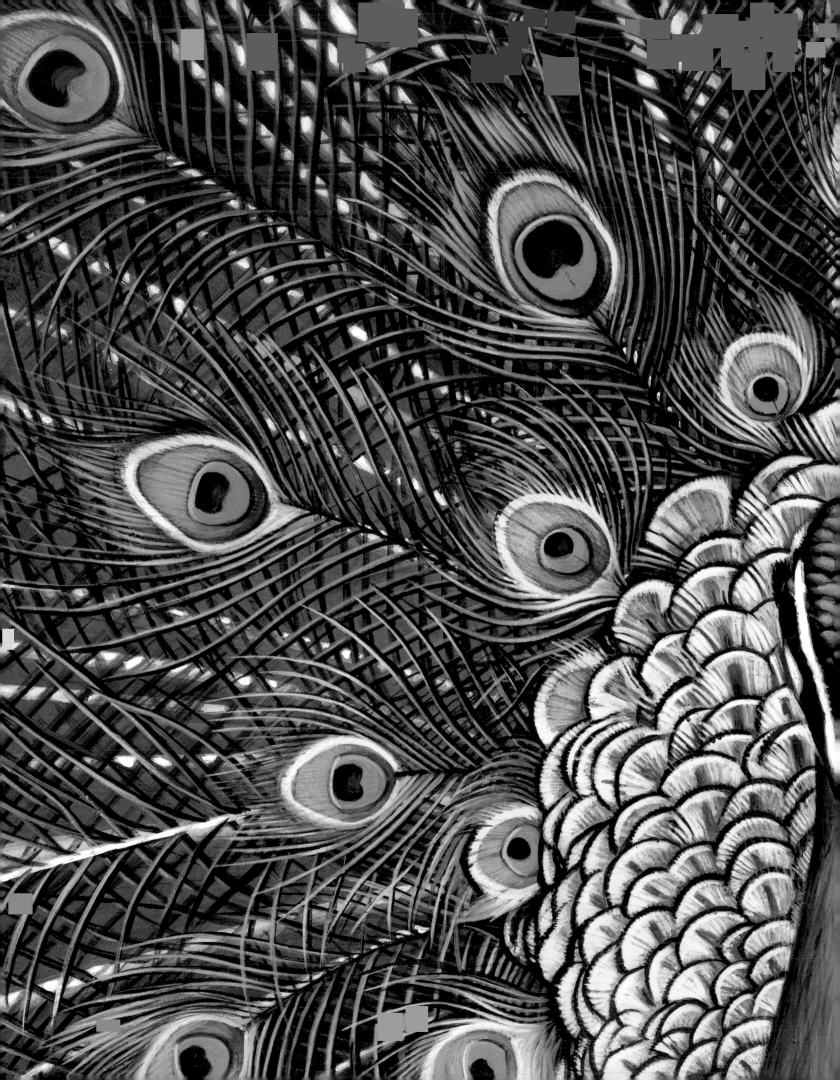

# The paintings in stages

# Peacock

Since ancient times, the peacock has been the symbol of the sun, which it represents when it fans out its tail. In China, India and Cambodia, it is identified with the solar energy that fertilizes the earth, its people and their souls. In the Christian world, it is the emblem of immortality and reminds us of the promise of the Resurrection.

The artist is drawn to the unique beauty of this bird. It is important to watch the peacock strut proudly around the paths of a park between March and the end of August, when his tail is at its most magnificent. He spreads his metallic blue and golden brown feathers with their yellow and turquoise eyes in a fan for the sole purpose of attracting the female. The plainer coloured peahen does not have the same grace. In subsequent months the peacock gradually loses his train and turns a more sober colour. He utters his distinctive cry less frequently, and no longer fans out his tail. It starts to grow again in November and reaches its full size in February.

To paint this imposing bird, Christophe Drochon has chosen a face-on composition. The feathers fanning out around the bird's head and breast appear to be projected forwards. The acrylic paints are pure matt colours. The bird has an austere beauty and an icy majesty. On the picture's dark ground, successive glazes bring out the lighter colours and create contrasts.

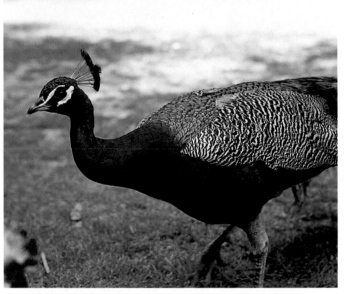

Sketching session. Christophe Drochon familiarizes himself with the animal, observing all its poses.

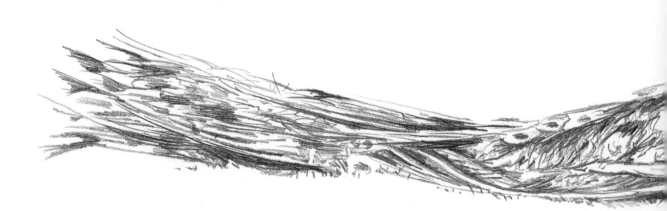

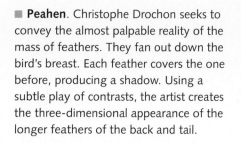

■ **Peahen**. Christophe Drochon seeks to convey the almost palpable reality of the mass of feathers. They fan out down the bird's breast. Each feather covers the one before, producing a shadow. Using a subtle play of contrasts, the artist creates the three-dimensional appearance of the longer feathers of the back and tail.

Conté pierre noire on paper, 21 x 14 cm (8¼ x 5½ in).

Conté pierre noire on paper, 22 x 12 cm (8¾ x 4¾ in).

■ **Peacock in profile**. This study shows the diversity of the peacock's feathers. The head, neck and breast are drawn in small fine lines, blended to form a grey tint. The short feathers of the tail are drawn in small waves. Stronger lines indicate the direction and the strength of the large tail feathers.

Conté pierre noire on paper, 15 x 34 cm (6 x 13½ in).

**1** The peacock fans out its majestic plumage over the entire surface of this picture. The subject is dealt with face on: the carefully balanced drawing is arranged on either side of a vertical mid-line. The top of the head is in the middle of the picture.

*materials*

- 180 gsm drawing paper
- Tracing paper
- HB pencils and Conté Pierre Noire
- Panel of fibreboard
- Universal primer or gesso
- Broad hog-hair graining brush No. 80
- Medium-size filbert brushes
- Very fine round sable-hair brushes
- Fine sandpaper
- Acrylic colours:
  mars black, burnt sienna, burnt umber,
  light purple violet,
  violet blue,
  light cadmium red,
  dark permanent green,
  hooker's green,
  yellow ochre, phthalo blue,
  ultramarine, turquoise blue,
  green-blue,
  light cadmium yellow,
  golden yellow,
  chromium oxide green,
  light emerald green,
  violet, orange.

**2** The head and body of the peacock are surrounded with short feathers out of which the longer ones from its tail fan out. The 'eyes' that adorn it are barely sketched. The drawing is then copied using tracing paper and transferred onto the support to be painted.

**3** The chosen support is a thin panel of fibreboard coated in gesso. The vivid colours of the feathers will appear more luminous against a dark ground. Two applications of dark colours, lighter in the centre of the panel, are necessary to achieve a sufficiently dense background.

**With the aid of the preliminary drawing**, the artist positions the contours of the bird's head, neck and breast. The quills of the big feathers, hollow at the base and ending as full shafts, are drawn with a ruler. These quills are painted with several successive applications of light colours until a near-white line is formed. The artist uses a narrow flat sable brush (5 or 6 mm/ ¼ in) to paint the fine lines.

He draws the curves using various spray guns.

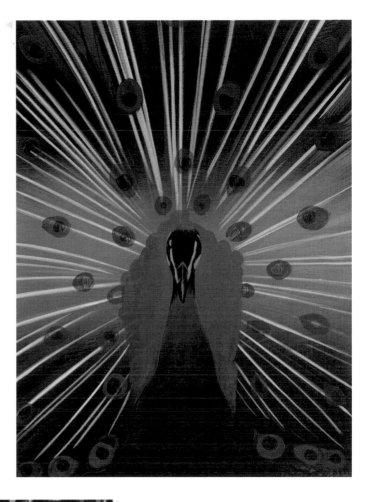

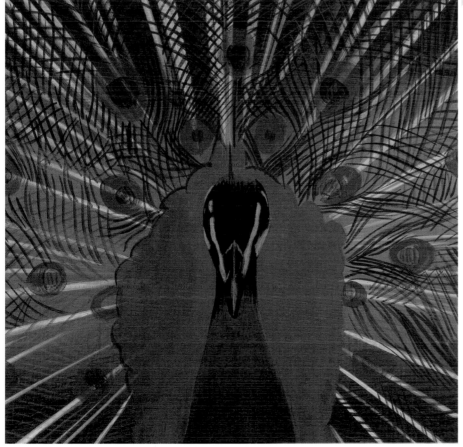

**Flat areas of base colours** mark out the surfaces: head in black, the neck in purplish ultramarine blue, the tail in burnt umber. The eyes on the feathers are represented by a series of small strokes of yellow ochre highlighted by a black point in the centre.

**Christophe Drochon begins work on the feathers** in the background. He draws the barbs with the tip of the paintbrush, starting from the shaft and working towards the top. The lines are fine, dark at first – sometimes enhanced with a touch of light cadmium red. Each one is made three-dimensional by adding shadow (in a dark tone: black, brown, hooker's green, emerald green) and light (yellow ochre). The lines intersect one another and lie over one another in a play of contrasts that adds depth. This work demands great concentration and an ability to anticipate. The artist has to keep the final effect he is striving for constantly in mind.

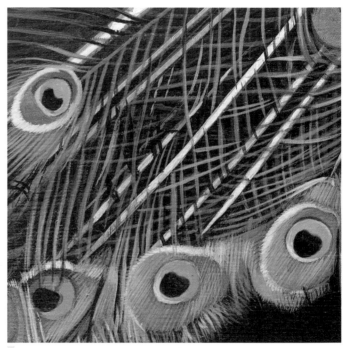

**Each feather** has close barbs in bright colours that appear dazzling when the peacock fans his tail. To recreate the harmony of that moment, the painter has begun at the bottom of the painting. The fine lines of the barbs are drawn lightly with the tip of the paintbrush.

It is important to try to understand **the structure of the feathers,** which determines the way they fan out. The colours used are light green, dark green, golden yellow and white. The eyes are created by an orange area surrounded by golden yellow. The black marking in the centre stands out against a ring of turquoise blue.

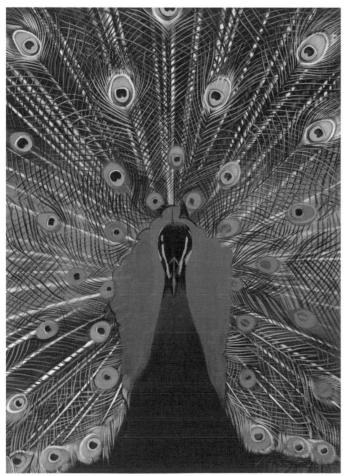

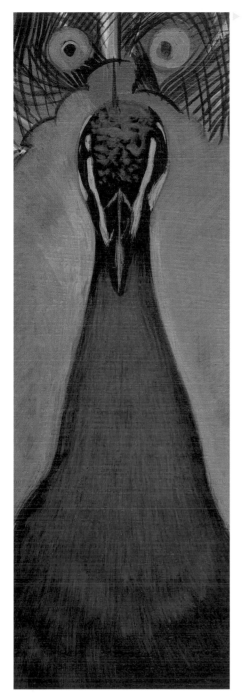

**9 The shades of blue** on the animal's body require a great deal of work. The artist begins with a dark ground, ultramarine and black, which he gradually lightens with phthalo blue and white in order to establish the contours. A glaze of very diluted phthalo blue adds the light. In the foreground, at the bottom of the painting, he applies small brushstrokes of ultramarine and violet.

**10 All the big feathers** are painted. The successive layers of lines of colour give a sense of density to the plumage. The lightest shades converge towards the centre and draw the viewer's eye towards the bird's head. With small brushstrokes of yellow ochre and orange, Christophe Drochon begins to paint the tail feathers, in the form of palmettes.

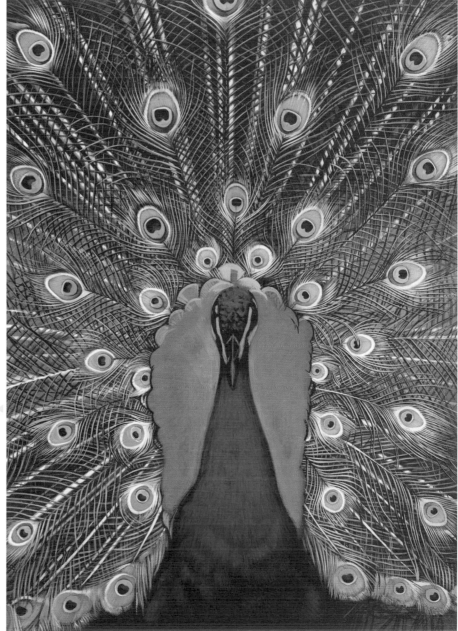

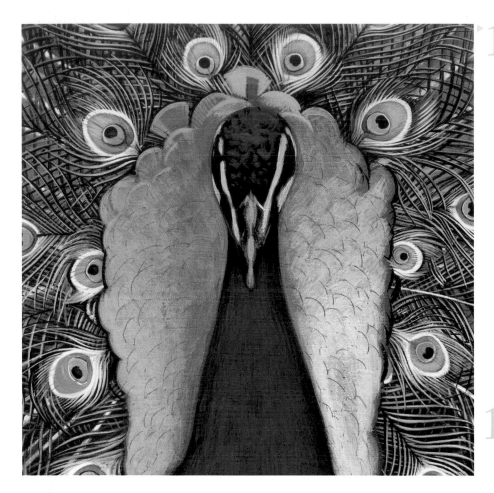

11 **The base of the tail** is lightened with tones of yellow more or less tinged with chromium oxide green, ultramarine blue and brown. To recreate the pattern of the feathers arranged like fish scales, the artist traces the drawing prepared earlier onto the painting when it is dry.

12 **The contours of the head and breast** are reworked with the tip of a fine paintbrush loaded with black. Small touches of yellow ochre are applied with a fine round paintbrush to the feathers of the ruff. A bluish-white line emphasizes the triangular shape of the head and bill.

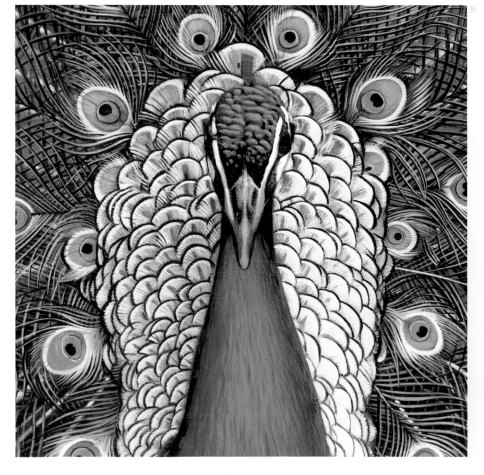

## The finished painting

*Siddhartha*, acrylic on fibreboard, 21 x 30 cm (8¼ x 12 in).

The contrasts are accentuated by a few touches of white on the feather shafts in the foreground.

The top of the head, the neck and the breast are lightened with ultramarine and turquoise blues; a purplish blue glaze brings out their brilliance. The short, fine brushstrokes suggest the flexibility and abundance of the feathers. A turquoise glaze applied to the neck lightens and accentuates the bearing of this magnificent peacock.

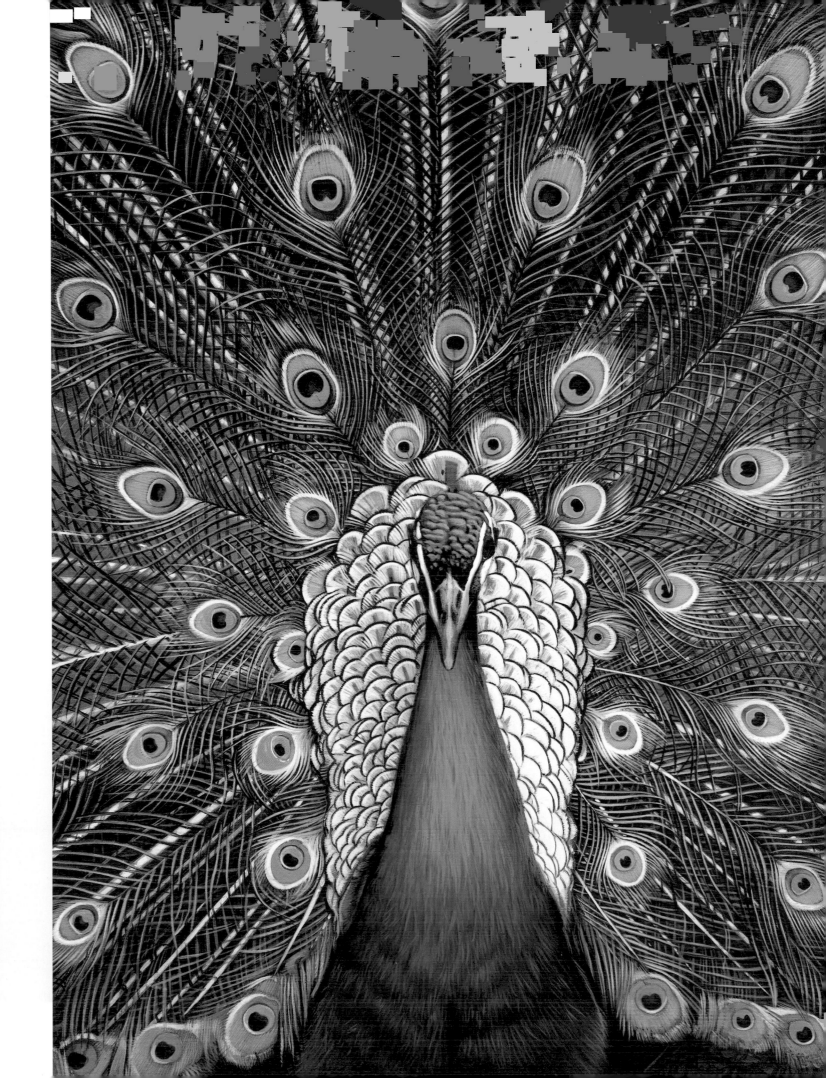

# From sketch to painting

The art of drawing is the art of moderation, restraint, economy of movement and means. Its power of suggestion lies entirely in the alliance the artist has developed with his tools. Among the graphite pencils, charcoal, stones and chalks, each artist instinctively finds what suits him to express his feelings. Christophe Drochon generally prefers Conté pierre noire, which is very responsive to the movements of his hand. Sharpened to a point or bevelled, it produces a thick or light, heavy or very soft line. Layers of hatching add substance, creating three-dimensional effects, especially when rendering the feathers of birds. When he moves on to painting, Christophe Drochon uses the same gestures with the paintbrush. His brushstrokes, light or heavy, and his layers of colours build up a work that is both realistic and profound.

## Preliminary sketches
Conté pierre noire on paper, 21 x 30 cm (8¼ x 12 in).

The head of the white peacock is drawn in various positions. It stands out against a grey background. The eye is expressive and the crest stands proud. The outline disappears in the close hatching of the background. Sketched with a light line, these quick studies allow the artist to choose an angle for his future painting.

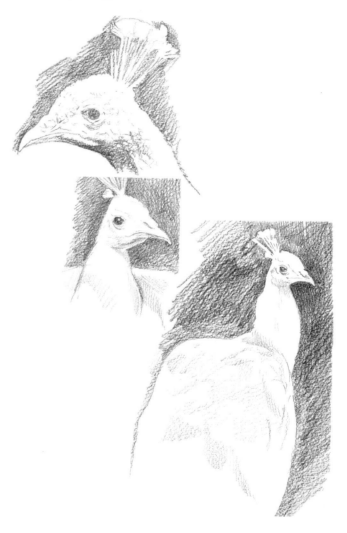

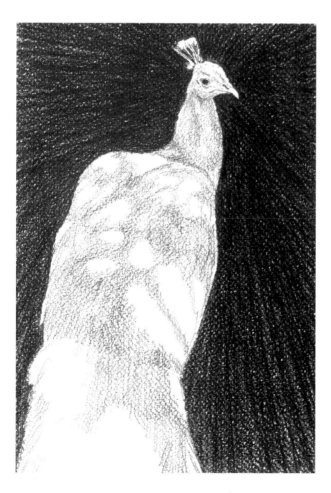

## Positioning the subject
Conté pierre noire on paper, 16 x 22 cm (6¼ x 8¾ in).

The artist makes the black background radiate around the peacock's head. The lines of Conté pierre noire are straight, heavy, thick and dense. The areas of shading in gradations of grey suggest the volume of the feathers. This is the majestic pose that he chooses for his painting.

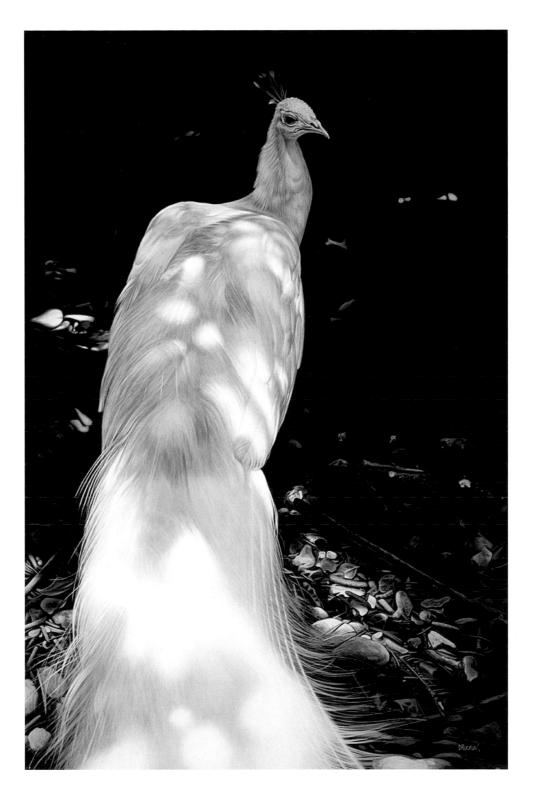

# The **finished** painting

*Shakyamuni*, acrylic on canvas, 73 x 48 cm (28¾ x 19 in).

The painter has placed his subject in the shade of a tree, which emphasizes its air of mystery. The main burst of bright light, on the peacock's immaculate tail, leads the onlooker's eye across a few light patches towards the bird's fine head. The shadows are lightly tinged with pink ochre and pale blue.

Glazes are applied in layers, creating volume and making the feathers stand out softly. The very dark background at the top of the composition and behind the head becomes lighter on the ground, which is strewn with dead leaves, twigs and pebbles. In the centre of this colourful universe, the white peacock observes the world, solemn and serene.

# Fox

Cunning, agile, wily, bold when in a hen house and timid near people, the "Master Fox" of the fables amuses children, but this predatory animal is the bane of farmers. All the tales and novels written about him highlight the duality of his character, hence his fascination.

A fox is not easy to spot. It is unusual to meet him out and about. He marauds at night, under cover of darkness. Christophe Drochon was able to observe a young fox enjoying semi-freedom on a private estate. The painter was charmed by the questioning, defiant, amused and tender expression of the fox's gaze.

In a wildlife park, in the shelter of his enclosure, this young fox allows himself to be approached...

■ **Study of the head**. The contours of the fox's head are shaped with successive red and orange washes.

Conté pierre noire and watercolour, 15 x 22 cm (6 x 8¾ in).

■ **Young fox**. The small lines in Conté pierre noire accentuate the bushy nature of the fox cub's fur.

Conté pierre noire and watercolour, 16 x 18 cm (6¼ x 7 in).

Conté pierre noire on paper, 32 x 38 cm
(12¾ x 15 in).

■ **The study of any subject** begins with lots of sketches from life. The artist observes his model for a long time from close quarters to get to know his personality. He does a series of drawings on the spot in Conté pierre noire, which he will use as references for his painting. He already has the spirit of his picture: the animal's ambivalent nature, which he will convey by painting the head of the fox in two parts, one in the shade, the other in full light.

Conté pierre noire on paper, 22 x 33 cm
(8¾ x 13 in).

## materials

- Canvas on frame 60 x 60 cm
  (23¾ x 23¾ in)
- Gesso
- 00 grade sandpaper
- 80 gsm sketchbook
- Pencil or Conté pierre noire lead
- Medium-sized, flat, round sable-hair
  filbert paintbrushes
- Fine and very fine round
  sable-hair brushes
- Gel medium
- Palette made of Rhodoid
  (cellulose acetate)
- Water
- Rags
- Acrylic colours: titanium white,
  mars black, mars yellow, raw sienna,
  burnt sienna, mars red, raw umber, burnt
  umber, ultramarine blue,
  light purple blue, phthalo blue,
  permanent light violet

**1** **On the white canvas**, Christophe Drochon draws the main lines of the fox's head, setting it at an oblique angle. The shapes of the eyes and nose are very precise. Using hatching, he indicates the direction of the fur, the areas of shadow and the position of the pupils. This detailed work will be covered by paint, but it enables the artist to commit to memory the arrangement of the surfaces, the rhythm of the lines and the intensity of the animal's gaze.

**2** **The light source** comes from the left of the picture. Strongly contrasting areas of shadow and light alternate on the fox's face. A dark background of mars black surrounds the animal's head. The colouring begins with the application of shades of burnt sienna.

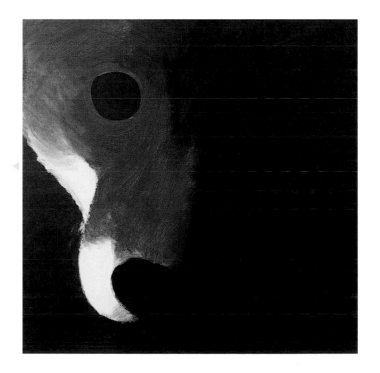

**3** The artist prepares warm brown colours on his palette. He mixes earth colours: burnt sienna, mars red and mars yellow. For the darkest areas, he adds mars black and blue. He lightens the more well-lit areas with a little white. The shapes of the shadows are marked out by adding layers of colour. The structure of the head begins to emerge.

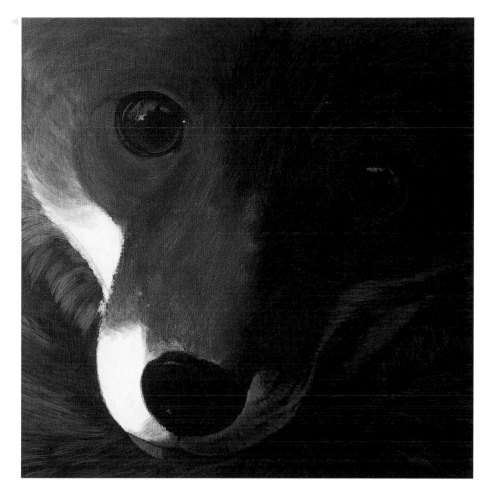

**4** The texture of the fur is suggested by more or less warm greys tinted with brown or blue. The direction of the fur is indicated, giving the coat its realism.

**5** Christophe Drochon pays particular attention to the animal's gaze. It is this that identifies the particular character of each species. Following the construction of the eye, the artist applies a first layer of colour to each area. He uses small fine sable brushes loaded with slightly fluid paint.

**6** **The areas of shadow on the nose** are reworked with lighter glazes to create the shape and the transitions that give balance to the picture.

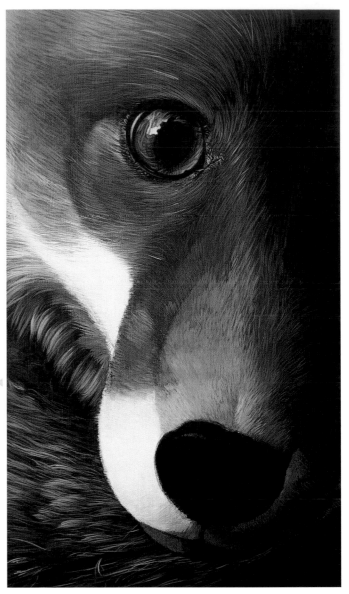

**7** **The artist begins to work on the russet fur**. He uses rounded filbert brushes worn at the side with fairly dry paints to obtain transparency and show the direction of the hairs. On the side the fur of the animal's throat is painted with a cat's tongue brush loaded with bluish grey and white in the light areas, and warm dark grey in the dark areas.

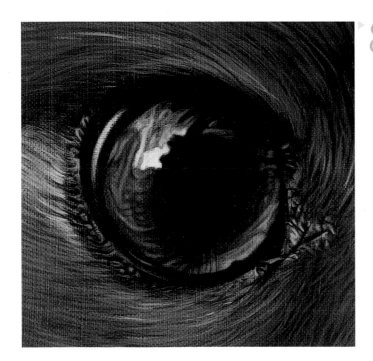

**8** **The eyelids** are rimmed with dark bluish grey; the iris shines with russet and golden tones; the pupil remains black. The artist goes over the work with the same shades, working in successive layers. He adds a little gel medium to the colours to obtain reflections and to harmonize the composition. The glints of light are created with very small touches of tinted white and gel medium.

**9** **To bring out the deep black of the nose**, the painter models the areas around it.
The animal's throat is painted with layers of more or less light bluish greys. The direction of the hairs is stressed by long thin brushstrokes of colour.

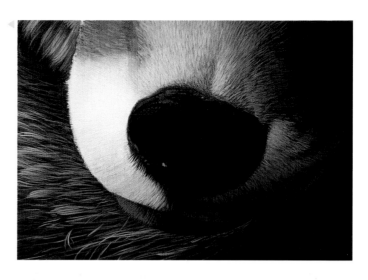

**10** **With a filbert brush**, he goes over the arch of the right eyebrow, which is in the light. He then progresses with light touches of paint applied with a semi-dry brush. This scumbling enables him to make the transition from the dark areas to the lightest areas. The brushstrokes are short and fine, in successive layers to represent the lie and thickness of the hairs.

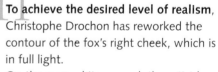

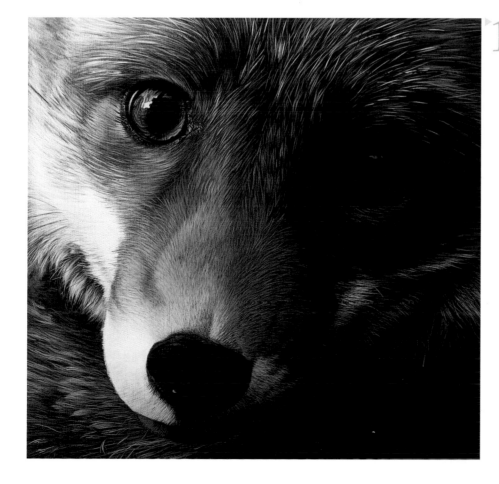

**11** **To achieve the desired level of realism**, Christophe Drochon has reworked the contour of the fox's right cheek, which is in full light.
On the pure white ground, the artist has applied glazes and small light touches to the pale ochre tones. The white and coloured hairs intermingle.
In the background, all around the head, the coat is longer, white and tinged slightly blue.
To obtain these shades, the painter has used different blues in his glazes with a touch of violet and raw sienna or raw umber.

**12** **With an almost new brush** smoothed to a slender point on the Rhodoid palette, he paints the dark hairs that stand out from the fox's muzzle.

**13** **With the tip of a new brush**, the painter draws some individual black hairs that appear in the animal's fur, as well as the eyebrows and whiskers. He goes back over the fox's left eye and retouches the outer shape of the eyelid.
On the surface of the eye in shadow, a shining point of bluish light brings the animal to life.

**14** **The finished painting**
*The Little Prince*, acrylic on canvas, 60 x 60 cm (23¾ x 23¾ in).
At the end of his long and patient work, Christophe Drochon takes care to establish the harmony of his painting. To warm up certain areas, he applies glazes based on gel medium diluted with water. This produces a sense of unity. After thorough drying, the painting is coated with gloss varnish.

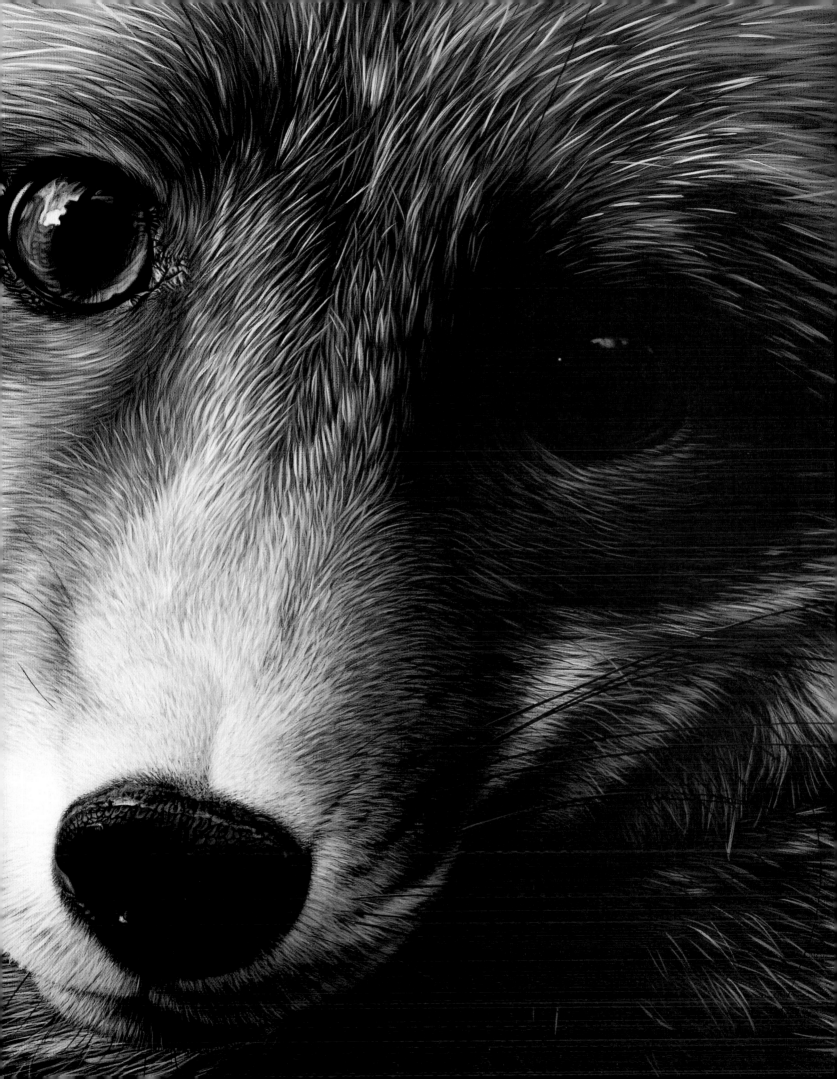

# From sketch to painting

Drawing is the foundation of all pictorial creation. It is part of the artist's research. A simple outline enables him to record the shapes of an animal, whether the subject is viewed from the front or in perspective. These are light quick sketches, done from life using a graphite pencil. Such sketches exercise the memory of both eye and hand. The preliminary drawing is more thorough, and a lot of hatching is used to bring out the volume. Areas of shade and light are shown. This chiaroscuro drawing allows the artist to fully take possession of his subject. So, when Christophe Drochon takes up his paintbrushes and paints, he can effortlessly recreate the contours of the chosen subject on the canvas. He can position the perspective and volume perfectly and is able to gauge their relative values.

## Preliminary sketches
Graphite pencil on paper, 20 x 22 cm (8 x 8¾ in).

To convey the soft appearance of the owl's down, the artist has chosen to draw it in pencil. The graphite lead allows a varied range of effects, from the fine line marking out the shapes to the hatching representing the shadows.
The tilt of the pencil and the pressure exerted on the lead allow the artist to create contrasts that produce a sense of volume. On the owl's body, very short lines indicate the direction of the small feathers. On the head, these are reduced practically to dots. The wing and tail feathers have well-defined markings, alternately grey and black (see also page 22).

## Setting the subject in its surroundings
Graphite pencil on paper, 17 x 24 cm (6¾ x 9½ in).

In this drawing in graphite pencil, Christophe Drochon has managed to convey the owl's full character: its watchful attitude and its intense gaze. Small hatching models the area around the eyes, which form black lakes.
In successive waves, the feathers suggested on the upper part of the body are made clearer and thicker as they descend towards the feet, which are gripping the branch. The lines become denser. The shadows create volume. The branches and leaves of the apple tree are drawn in varying shades of grey. The layers of cross hatching define the contrasts between shadow and light. The whole drawing is distinctive for its delicacy and truth.

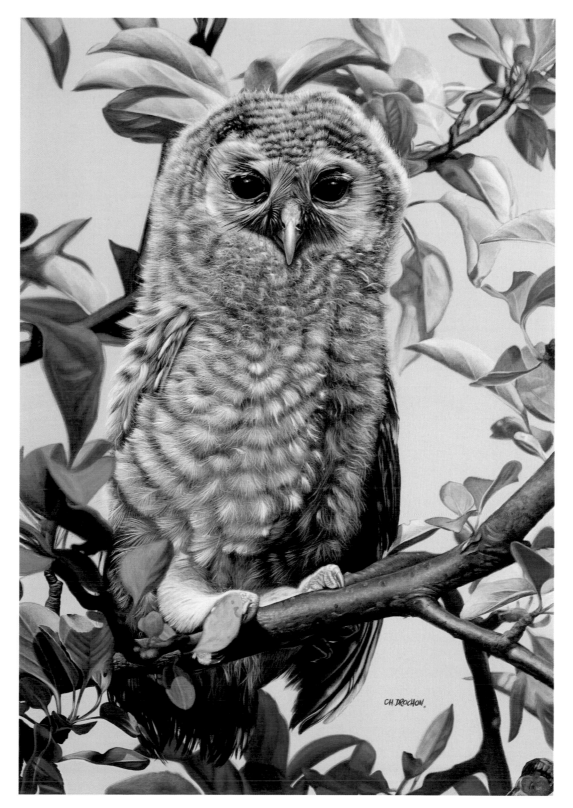

# The **finished** painting

*Eyes within eyes*, acrylic on canvas, 55 x 38 cm (21¾ x 15 in).

In the same concern for truth, the artist has painted this owl against a background of blue sky, evoking the end of the day. The golden light catches the little feathers of the bird's head and body. Dark in the lower layers, the colours become lighter at the surface. Small fine pale brushstrokes suggest the downy appearance of the plumage heated by the rays of late sunshine. The branches and leaves of the apple tree are painted with less precision, which helps make the subject stand out. Only the branch on which the animal is perched is painted in great detail.

# Canada Goose

In Egypt, China and Ancient Rome, wild geese were considered heavenly messengers. With their cries they announced happy events such as the anointing of a new Pharaoh, or dangerous events such as the attack on the Capitol by the Gauls. Messengers of love too, they became the symbol of marital fidelity throughout the world.

Among the various species of wild geese, the Canada goose is a good size. Its plumage is brown, mixed with white, black and sometimes reddish-brown. It lives mainly in northern regions and migrates south in winter, covering very great distances. Its body is compact and its wings powerful. Its long neck projects its head forwards. Its shapes are graceful and sober. Christophe Drochon has found in the noble bearing of this bird a certain expression of purity. He has made it the subject of a painting of simple lines and few colours.

In the wildlife park, it is easy to approach a wild goose. Christophe Drochon takes advantage of this to observe the bird and make some quick sketches.

84

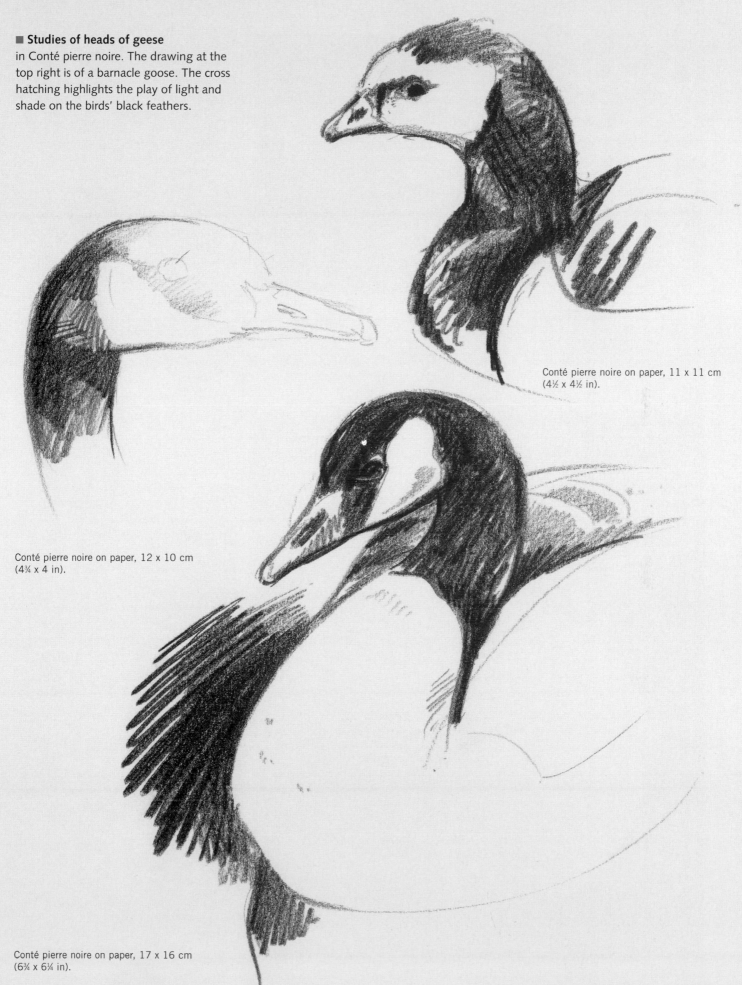

**■ Studies of heads of geese**
in Conté pierre noire. The drawing at the top right is of a barnacle goose. The cross hatching highlights the play of light and shade on the birds' black feathers.

Conté pierre noire on paper, 11 x 11 cm (4½ x 4½ in).

Conté pierre noire on paper, 12 x 10 cm (4¾ x 4 in).

Conté pierre noire on paper, 17 x 16 cm (6¾ x 6¼ in).

**1** **The canvas** is first entirely coated with gesso, then sanded to obtain a fine surface. To save drying time, Christophe Drochon uses acrylic paints.
The ground is composed of mars black with the addition of a trace of burnt sienna. The application of two coats of colour is recommended. Once it is completely dry, the artist draws the outline of the goose with an HB pencil lead.

## materials

- Canvas on frame 65 x 54 cm (23½ x 21¼ in)
- Gesso
- Grade 00 sandpaper
- Wide graining brush, foam roller (15 cm/6 in wide)
- Worn, rounded sable filbert brushes in all sizes
- Wide hog-hair brush
- Sponge and rag
- Retouching varnish
- Painting medium
- Gloss varnish
- Acrylic paints: mars black, burnt sienna, phthalo blue
- Oil paints: mars black, manganese blue, phthalo blue, dark ultramarine blue, tuareg blue, yellow ochre, brown ochre, pale cadmium yellow, vermillion red, titanium white

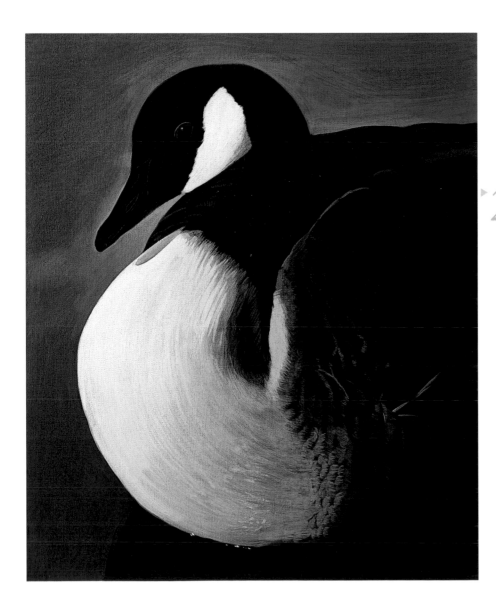

**2** **He then proceeds** to apply acrylic paints: a patch of titanium white on the side of the head; some creamy whites shaded with a little phthalo blue on the most well-lit part of the crop and burnt sienna on the shaded part of the goose's belly. The strengths are medium. Fairly dry brushstrokes, in the direction of the feathers, create the volume.
To represent the water, he uses a mixture of phthalo blue and black. Around the head and back of the bird, the tint is lightened with manganese blue. A white point of light applied to the eye brings the bird to life.

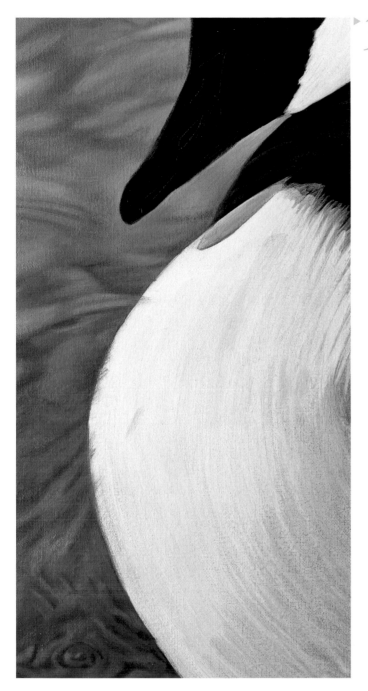

**The work in progress** is entirely coated with retouching varnish to create a bond between the acrylic and the oil paint to be used afterwards. Christophe Drochon begins by painting the water of the background. He mixes various blues: tuareg, manganese and phthalo. The strokes of the filbert brush are relatively loose; the edges of the subject are blurred with a flat dry brush. In the goose's dark reflection on the water, the artist adds shades of yellow ochre and brown ochre, creating a transparent effect.

**The back and the wing behind the neck** are worked with flat sable brushes. The tones remain sombre: mars black, ultramarine blue and brown ochre. The wing in the foreground has more contrasts: the edge of the feathers is lit by small touches of ochre, blue and white.
The painter applies light colours onto dark grounds, suggesting the shapes and volume of the feathers.

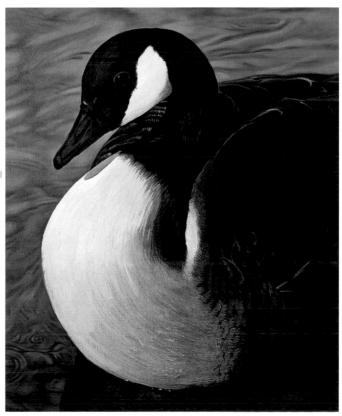

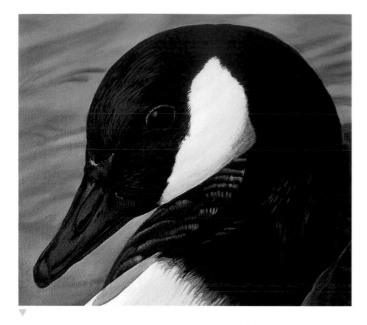

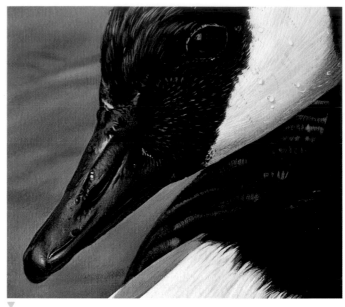

**5** The head and neck remain the darkest areas of the subject. The artist works in light brushstrokes, applying shades of blue enriched with brown tints. He follows the lie of the feathers. The bill, in full light, is made slightly lighter. The almost white cheek and the crop are shaped with the tip of a fine brush. On the palette, the white is delicately tinted with yellow, red or blue to give a three-dimensional effect. The painting takes four days to dry.

**6** Christophe Drochon reworks the head and the neck. He applies retouching varnish to the surface to be painted. He models the bill and gives it a glossy appearance. Using a fine paintbrush, he shows the orientation of the small black feathers on the head, which become blue in the light. The eye is surrounded by a fine light line and marked with a small glint of light. The bird's pale cheek, shaded at the edge, gradually acquires volume.

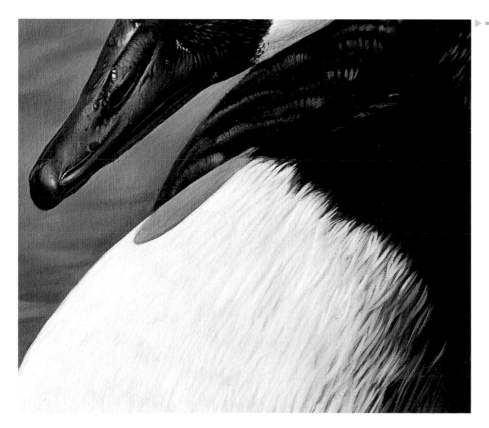

**7** The graduation of dark towards light is punctuated by imaginary horizontal lines that mark the way the feathers lie over one another. This adds to the impression of volume. The shadow of the bill on the white feathers is suggested by a blue patch.

8 **The painter approaches the dark tints** with final colours. His range is composed of browns and blues mixed with some touches of white, red and yellow ochre to reproduce the vibrations of the light.

On the plumage, the work of the glazes is made easier by the use of painting medium. At the wing joint, the shadows in the hollow of the neck are done in cold bluish shades.

9 **The painting is left to dry for several days**, then it is again coated with retouching varnish. The work resumes with highlighting the most luminous colours over the whole painting. The artist paints the feathers individually, while keeping to the spirit of the overall vision. Each lit area is edged by its shadow, creating the contrast necessary for a three-dimensional effect. The head and bill are also reworked. Very small touches of white are added with the tip of a fine paintbrush to suggest the fine beads of water on the feathers.

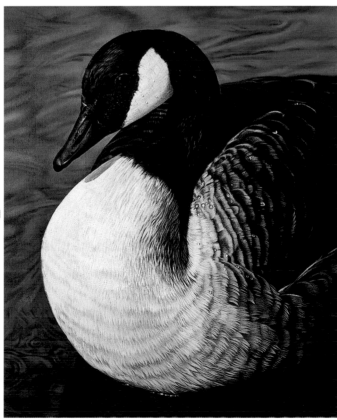

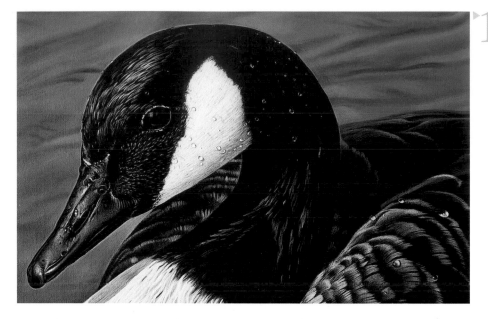

**10** **Further glazes** create a play of light over the whole subject.
Lit up, the head and neck stand out clearly. Light and texture are defined and balanced with the goose's body.

**11** **Christophe Drochon goes back over the darkest areas**. Once the painting is thoroughly dry, he applies a glaze to the bird's body tinted with light brown ochre and yellow ochre, enriched with a touch of manganese blue. Then he goes over the shapes of the small feathers of the wing in the foreground.

**12** **Finished painting**

*Farewell melancholy*, oil on acrylic ground, 65 x 54 cm (25½ x 21¾ in).

Christophe Drochon leaves it to dry once more. He finishes the composition with the application of a very light glaze mixed with brown ochre and a little yellow ochre. This warms and harmonizes the overall tonality of the painting. After several weeks of drying, the painting is varnished.

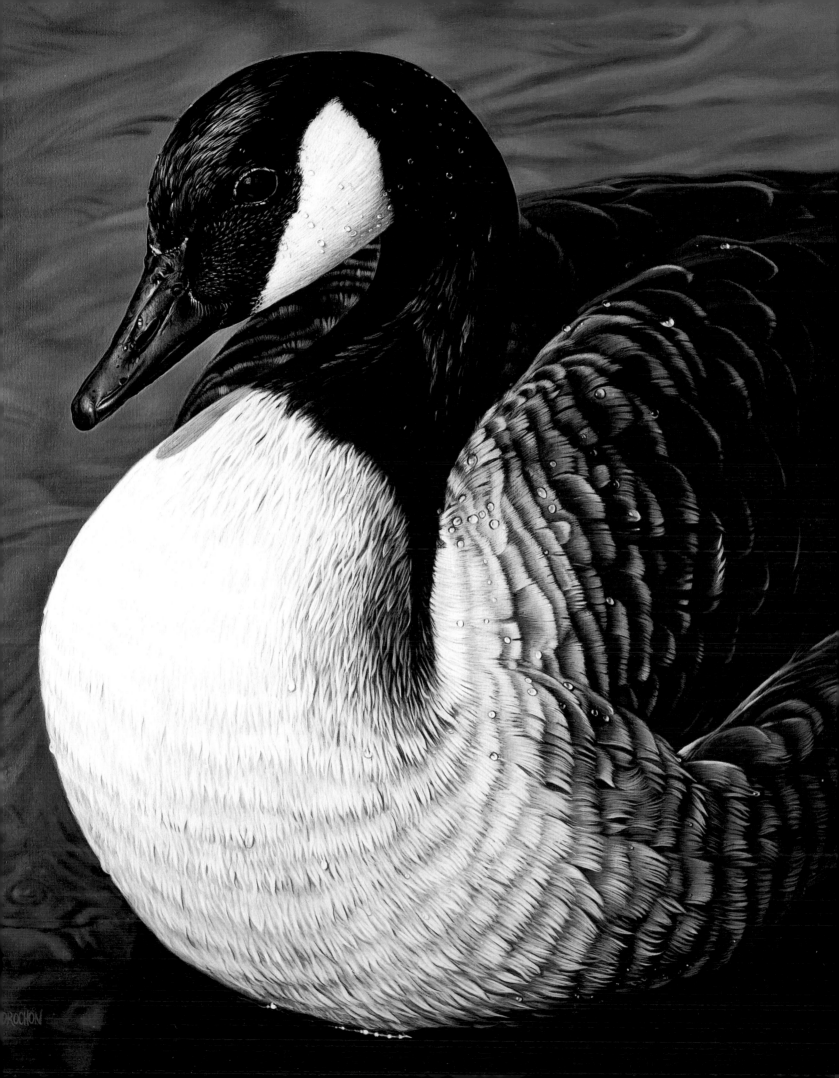

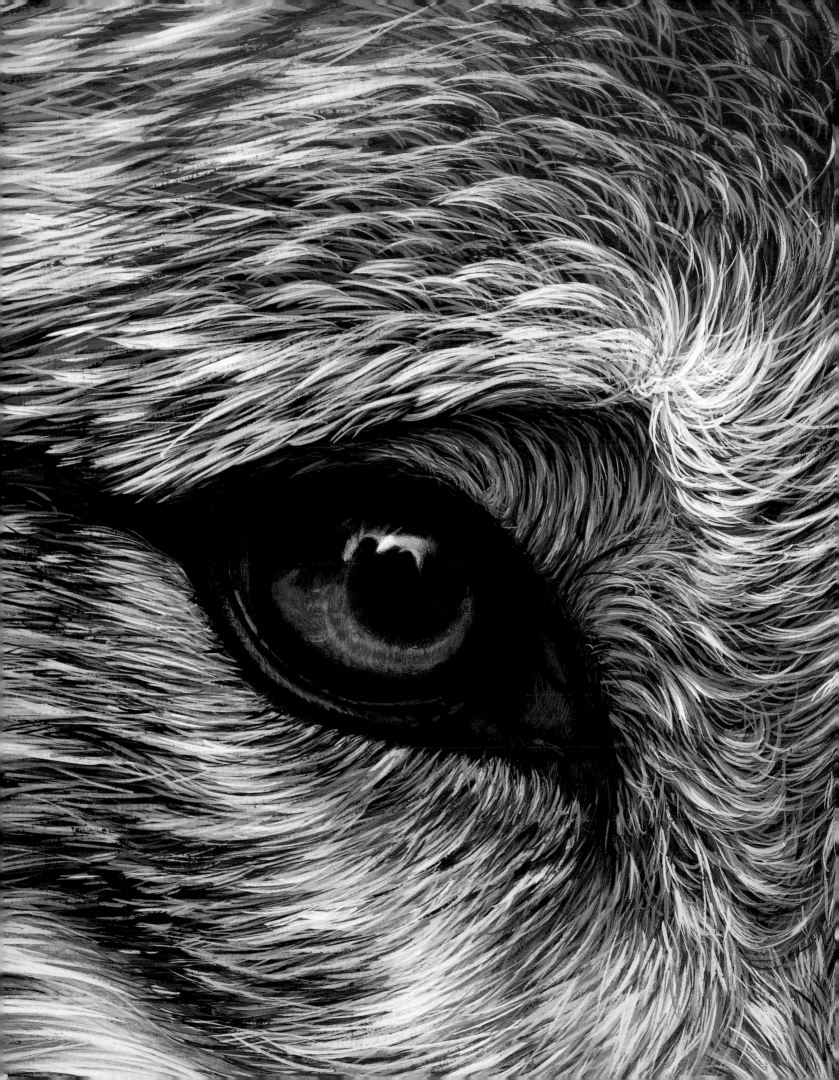

Gallery

# Master of Mysteries

Acrylic on canvas, 50 x 50 cm (19¾ x 19¾ in).

What secrets are hidden in the eagle owl's impenetrable gaze! This solitary bird of prey with its impressive wingspan never faces the light of day. It is disturbing and fascinating at the same time: a symbol of death to some, of sorcery to others, it is unjustly attributed with many ills... Christophe Drochon has made it the master of mystery.

To render the disturbing intensity of its gaze, the artist has chosen a very close composition. The eyes of this large owl, rimmed with black, invade the space with their unusual red colour. They stare at the viewer as though they wish to share something with him. It is impossible not to be bewitched by this animal that is as majestic as it is enigmatic.

■ **The bill**. Viewed face on, the strongly hooked bill shows the power of this bird of prey. The impression is accentuated by the flashes of light on the deep bluish black.

■ **The feathers**. On top of the dark and coloured ground layers, increasingly light glazes have been added. With very fine paintbrushes, the artist has repeated the drawing of the feathers, with their black shafts and grey and white barbs.

■ **The eyes**. The light plays on the orange-red iris of the bird's eye as though in a mirror. The effect is conveyed by a layering of small brushstrokes in varied tones. The indispensable point of more yellow light orientates the gaze.

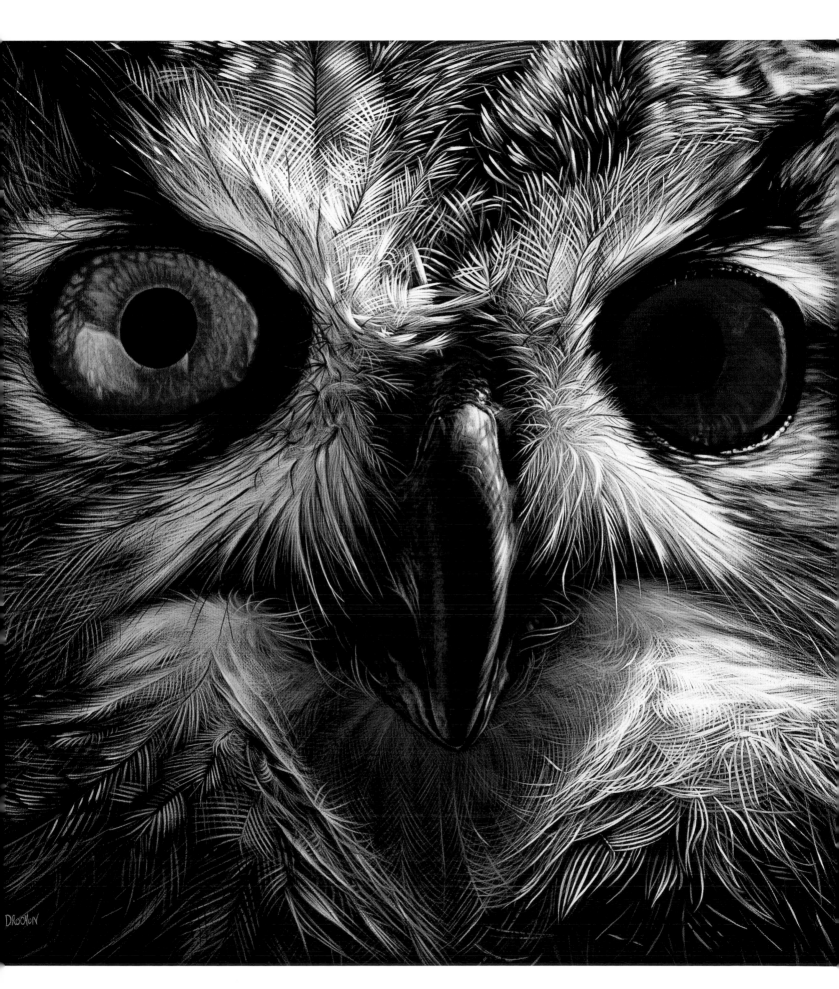

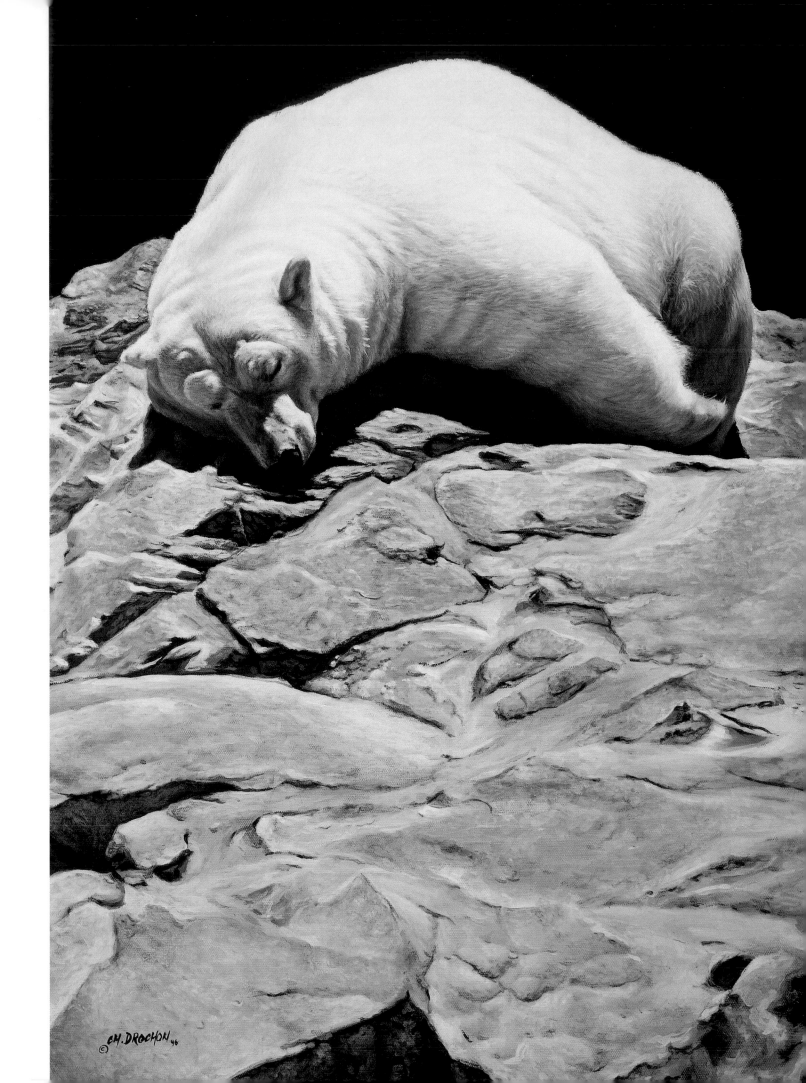

# Sleeping Polar Bear

Oil on canvas, 55 x 38 cm (21¾ x 15 in).

I n a zoo, on an area of grey-coloured flat rocks on an ice floe, a polar bear lay asleep. Christophe Drochon had long wanted to paint a picture portraying contrasts and oppositions: this animal seemed an ideal subject. He first made a few sketches, to choose a spectacular viewpoint. The composition is divided into three parts; the bear occupies only the upper third. All the light of the painting is concentrated on the animal's back, which stands out against a black background.

The polar bear is not white, as is generally thought. This means it can be worked in warm shades (white mixed with ochres, yellows and oranges), especially in the areas of shade of the fur lit by a reflection of the light on the rock.

The central part is worked in greys edged by the almost black shadow of the bear on the rocks. A new contrast is established: that of the shapes. The sleeping bear offers a compact mass, rounded and soft, which contrasts with the fractured and brittle lines of the rock. In the foreground, the larger lighter stones occupy the remaining third of the surface. The perspective thus created leads the eye of the viewer from the bottom to the top, where the animal is lying.

■ **The fur**. The sun is at its zenith: the light falls vertically and brings warmth and wellbeing to the mammal.
Its fur is tinted with a thousand shades. The warm grey and beige tones contrast with the cold blue greys of the rocks.

■ **The rocks**. The animal's body, a soft, warm, round mass, contrasts with the almost palpable hardness of the ground. A clash between light and shadow, warmth and cold, tenderness and brutality, this painting is above all an ode to life.

■ **The bear's head**. Christophe Drochon paints in increasingly light layers to achieve the desired tones. The upper layers are fine glazes allowing sweeping transitions from the areas of shadow towards the light, above the closed eyes, the arches of the eyebrows and on the cheek.

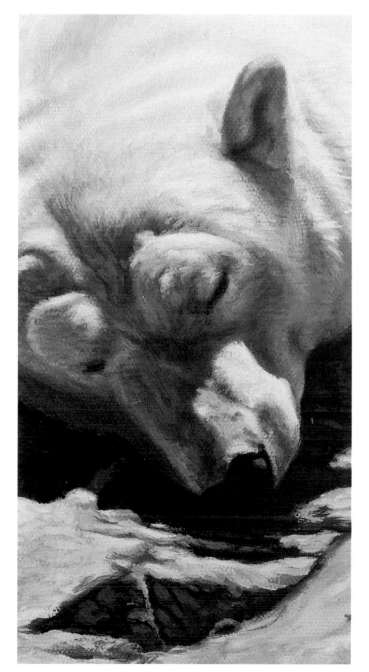

# Deer's Eye

Acrylic on canvas, 55 x 46 cm (21¾ x 18¼ in).

The doe is an elegant animal, with fine slender lines. It evokes delicacy and femininity. Its beauty also lies in the extraordinary glint in its eyes: as soft as they are captivating, they are often used to describe the eyes of a young girl.

It is easier to see does in wildlife parks than in the wild. Christophe Drochon was able to get very close to one. He observed and studied it and took inspiration from it to compose this piece in an almost rectangular format, which is both fascinating and disturbing: a gigantic eye, a perfect globe, reflecting the landscape like a distorting mirror. The eye is like a door into a strange and mysterious world: like Alice, you have to go through the looking glass and plunge into the darkness of the pupil to gradually penetrate this wild and bewitching forest – at the risk of getting lost in it. The animal and the forest are but one.

The doe's dense fur is painted in layers of glazes. Each brushstroke brings out the tangled mass of brown, pale ochre, greenish, black and white hairs.

■ **The eye**. By getting as close as possible to the animal's eye, the artist tries to penetrate its secrets. In the brilliant crystalline lens, he suggests the surrounding vegetation, shot through with light. In the centre of the pupil, a blue point orients the gaze.

■ **The fur**. Beneath the fur – which in reality is more coarse than soft – you can sense the folds of skin. This effect is achieved by the position of the shadows beneath the lit areas of the fur. The brushstrokes are more or less short to show the different lines of growth of the hair. Increasingly light, the shades are layered from black to white, passing through the whole range of browns and russets.

98

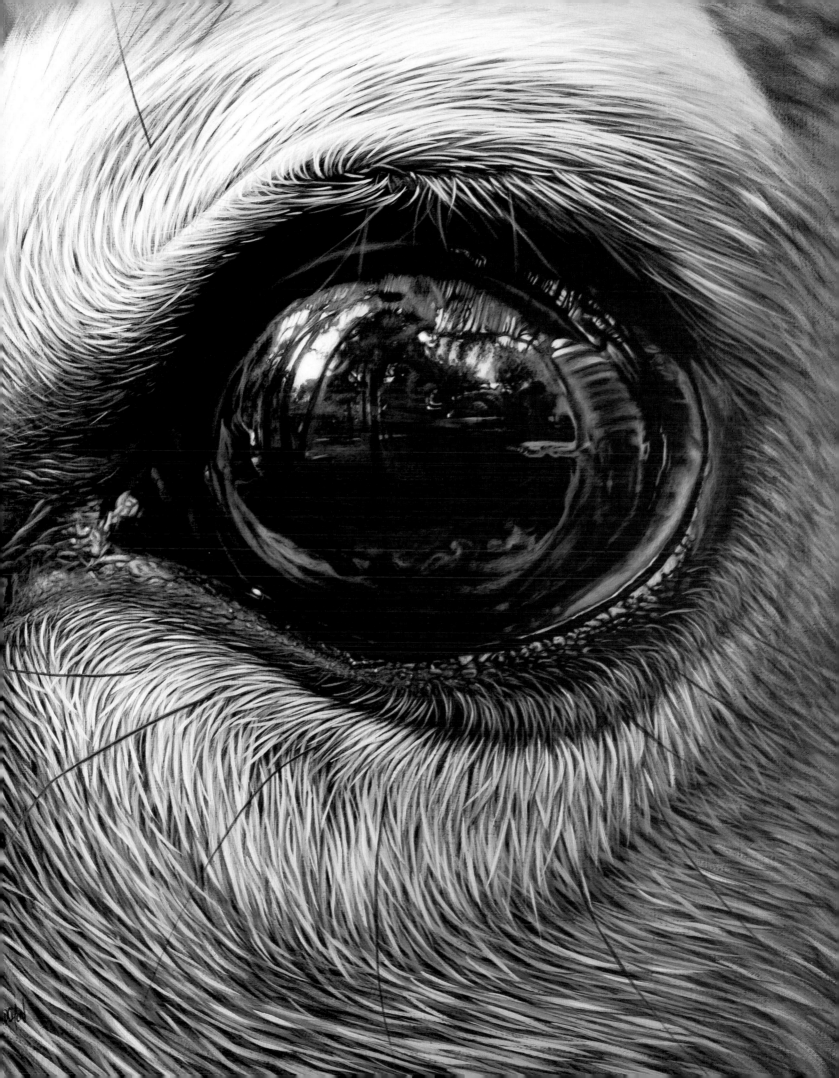

# The Storm

Acrylic on fibreboard, 47 x 33 cm (18½ x 13 in).

In December 1999, a particularly violent storm swept through France. The countryside was transformed into a scene of desolation: broken branches, torn-up trees, devastated forests... Concerned by what the forces of nature had brought down on man and beasts, the artist devised a painting in a vertical format. This choice, as though restoring the original position of the trees, was also to commemorate the event and announce the rebirth that would follow.

A blackbird, a small modest bird that might be said to have a resigned air, is posed by the artist on a broken tree trunk. The contrast between the deep black of its plumage and the light colour of the torn wood is striking. Christophe Drochon has used a pyramid-shaped composition: the viewer's eye is drawn from bottom to top, towards the bird's eye circled with gold. The bird is positioned behind the broken tree trunk. Seeking to evoke the renewal of nature, the artist has deliberately painted the background in varying shades of green.

■ **The blackbird**. The bird's feathers shine in the sun. Their inky black is tinged with purple and bluish glints. The bright eye is lit by a white point, the bill by a gleaming yellow. A symbol of hope, this bird is alive and ready to take flight.

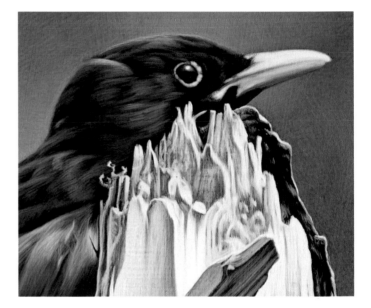

■ **The trunk**. The wood fibres are in various shades of yellow, white and pink.... They are done in layered glazes to bring out the minute details of their three-dimensional forms. Each lit surface is highlighted by the shadow surrounding it.

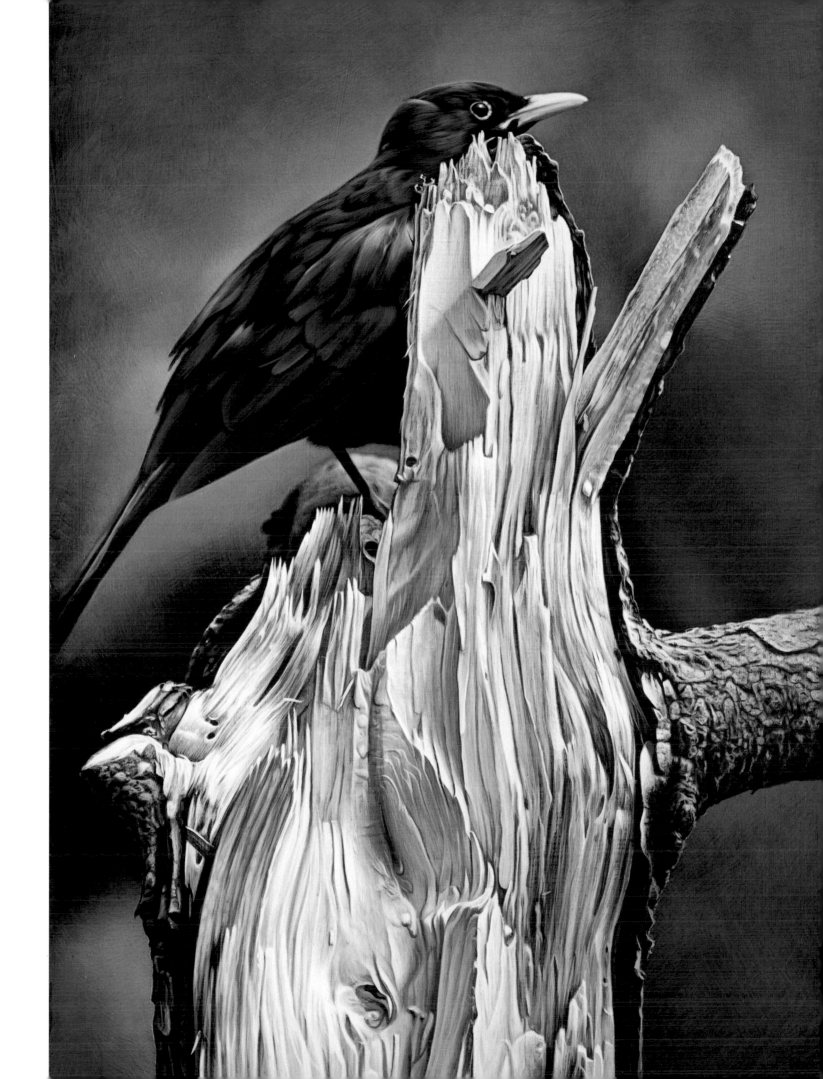

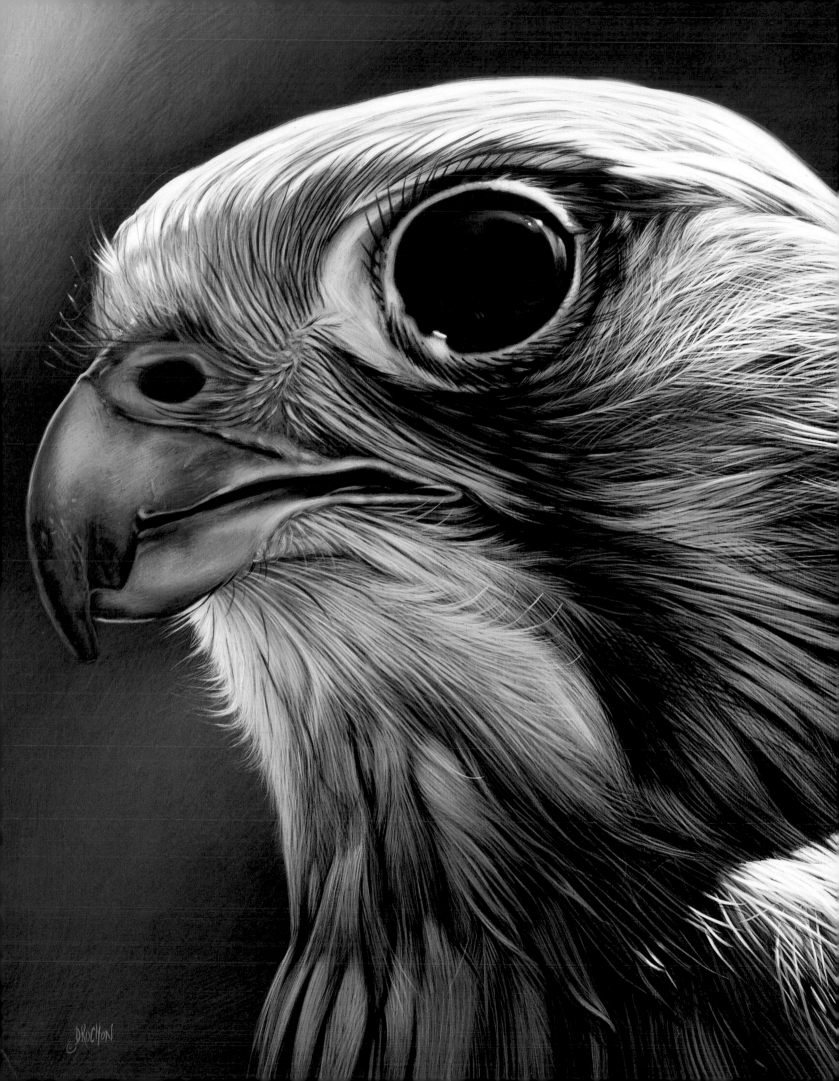

# The Holy Spirit

Acrylic on masonite, 28 x 29 cm (11 x 11½ in).

The characteristic flight of the kestrel, hovering perfectly still in the sky above its prey, is often likened in France to the Holy Spirit hovering like the dove of the Gospel.

The kestrel's colours are stronger and more varied than those of its cousin the peregrine falcon. Very widespread in Europe, this small bird of prey has reddish brown, dark brown and slate grey feathers.

In this composition with its almost square format, the artist has allowed himself to adapt the bird's colours slightly. Indeed, in reality, the plumage of the head of the male is grey, that of the female, rather reddish. Here, these differences are removed, and the head, haloed with an intense very white light, stands out against the black background, in order to stress the symbolic aspect of the animal.

The painter has chosen a harmony of blues for all the plumage. The shadows are done in greys and blacks, a bright yellow surrounds the eye and the bill and the small feathers of the crop are enhanced with red tints.

■ **The eye**. The eyes of birds have no visible lids. The eye's black globe is defined by a yellow membrane. The point of light, placed right at the top, at the edge of the eye, adds to the mystery of its gaze.

■ **The bill**. The kestrel's bill is short and very hooked, dark in colour and shiny. In the shadow it harmonizes with the whole of the plumage with its dominant blues. The nostril surrounded by yellow, above the bill, resembles an eye.

# The Jade Spring

Acrylic on canvas, 100 x 100 cm (39½ x 39½ in).

I n the African savannah where the dry season is often long, the watering hole is the only chance of survival for animals. Looked at carefully, you could compare the eye of the leopard to a spring of pure water. It has the clarity, limpidity and colour of jade, symbol of life and immortality. In contrast, with its ochre shades and dark markings, the fur that encircles it might evoke the aridity of the inhospitable land. It reminds us that the leopard is a wild and savage animal, with fast reflexes. It is this confrontation between two worlds that Christophe Drochon expresses here, in a powerful and expressive painting. The square format of the painting adds to the idea of isolation and danger that threatens the fragile water source, reminding us that life is precious.

The eye dominates the composition by the precision of its drawing and by the choice of its colours. These are liquid and almost unreal. The treatment of the fur is particularly delicate. The layers of colour – which go from darkest to lightest – enable this perfect modelling around the eye in close-up, to accentuate its brilliance.

■ **The eye**. By choosing pale blues and turquoises and toned down whites, the painter bathes the leopard's eye in a limpid, unreal and soft water. The cat is looking towards the sky, towards the light, as though waiting for an impossible answer.

■ **The fur**. Beneath the eye, the short hairs, the lightest ones, are painted in layers of ochre, yellow and white tones with the tip of the paintbrush, following the rippling movement of the fur. They meet the russet, brown and black markings and are tangled up to give an impression of softness.

■ **The upper eyelid**. You cannot so much see this as guess it is there from the black edge it forms at the rim of the eye and its shadow on the iris. The golden eyelashes painted above give further depth.

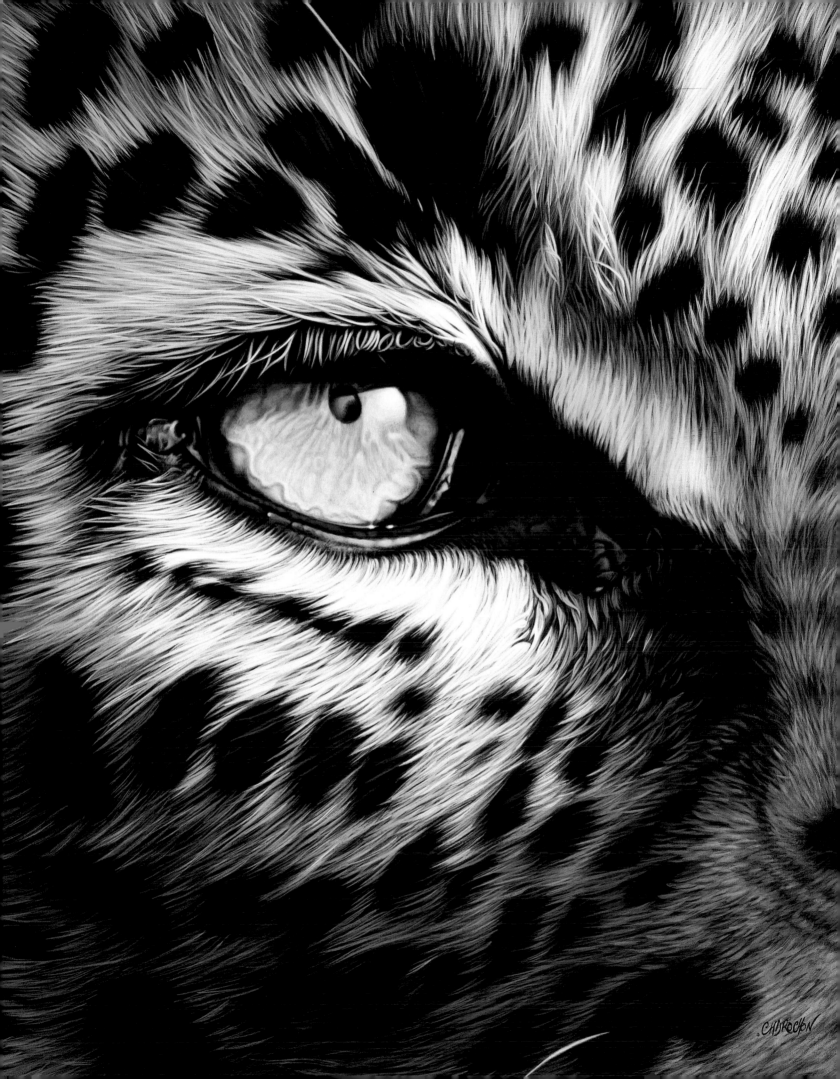

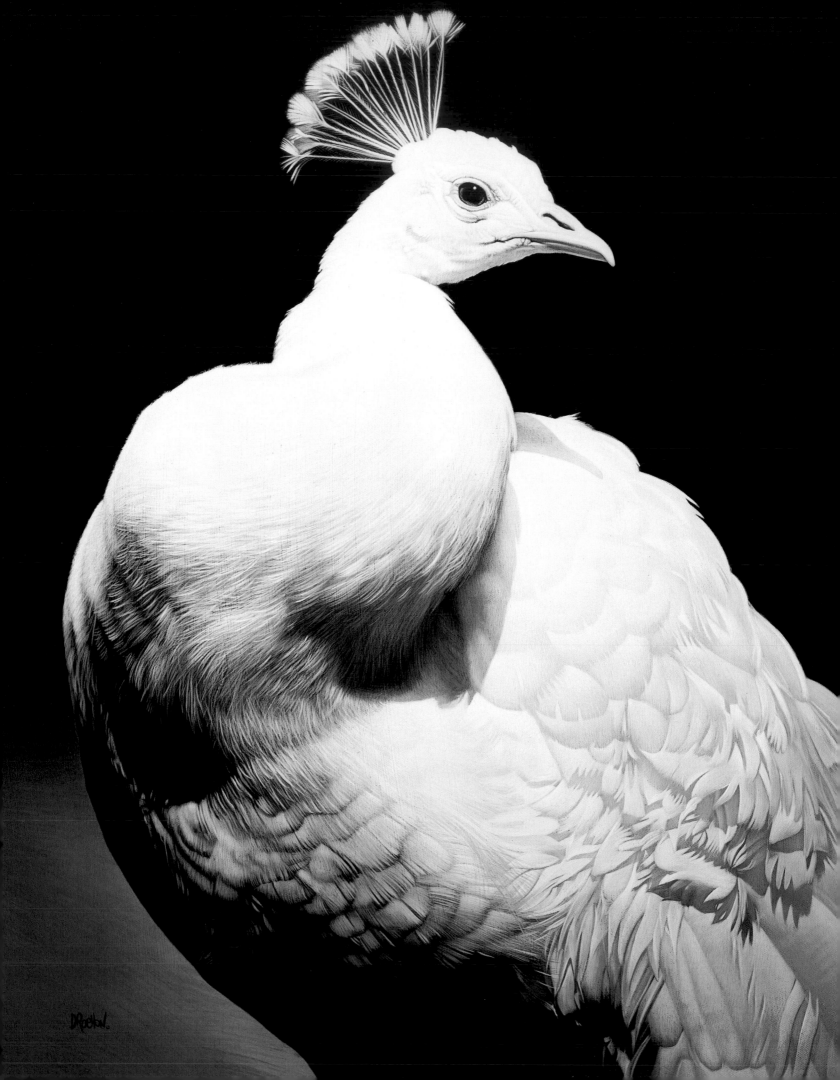

# Galahad

Acrylic on canvas, 81 x 65 cm (32 x 25½ in).

Because of its majestic appearance and its colourful feathers, the peacock is often used to evoke the image of vanity. The white peacock is quite another matter: devoid of pigmentation, its "spirit" is open to the light.

Representative of the pure being, Christophe Drochon compares it to Galahad, the son of Lancelot, a chaste and perfect knight who, according to mythology, had the privilege of glimpsing the Holy Grail.

In this depiction, the peacock, flooded with a celestial light, is turning towards the viewer, offering him its immaculate whiteness. The almost black background clearly isolates the bird and highlights the silhouette of the head, which is crowned with a crest. The work on the wing feather,s which are back-lit, creates a special point of attraction that balances the composition. The dramatic shadows place the emblematic animal in the transfigured and unreal world the painter wishes to create.

■ **The head**. With its neck turned back towards its wing, the peacock regards the viewer sharply. The bill is very slightly tinged with pink.

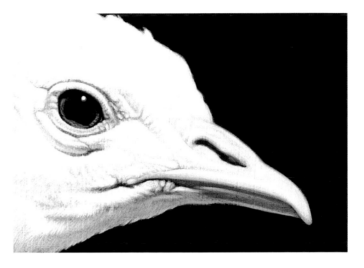

■ **The right wing**. Through small brushstrokes of bluish or slightly pinkish white, the artist creates areas of shadow and light that bring out the fineness of the shaded layers of feathers.

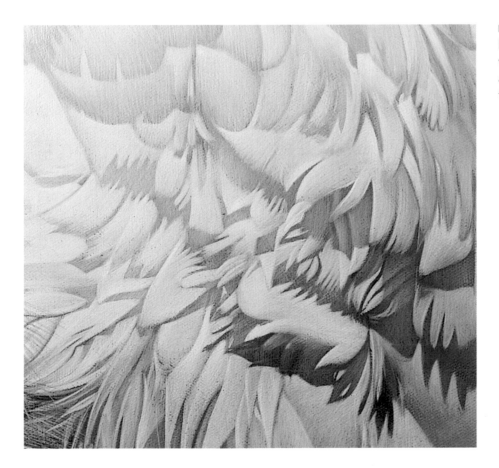

# Margot the Magpie

Acrylic on illustration board, 35 x 25.5 cm (13¾ x 10 in).

She has a bad reputation: she is called a chatterbox, a thief and a harbinger of rain and ill omens, but she has a pretty name and can also bring happiness to the home, when two are spotted together. She is known familiarly in France as "Margot", which means "pearl", because of a large white marking on the base of each of her wings: a light in the middle of her black plumage. Indeed, the magpie is a large bird of the crow family. She has their dark colours and sharp eye.

In this painting, the bird is presented with its head standing out against a dark grey background. The sobriety of the setting creates a dramatic effect. The bird is not shown in full; paradoxically, this composition strengthens the presence of the subject and gives it an even more provocative air.

The plumage is painted in layered glazes. To render the shiny and iridescent appearance of the feathers, the artist enriches his blacks with touches of blue and purple. The slightly unfurled wing lets us glimpse the white markings and the beginning of the long metallic blue feathers.

■ **The bill and the eye.** The bill is powerful, hard and smooth. It shines with the slightest ray of light. The round eye has the appearance of a crystal ball of a deep and disturbing black. The bird seems to be examining the viewer with a mocking and inquisitive look.

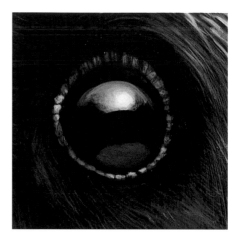

■ **The wing**. Methodically, by placing a touch of light on a dark ground, the artist makes the form and volume of each group of small black feathers stand out. This layering gives the wing three dimensions from which spring the long feathers with their blue glints.

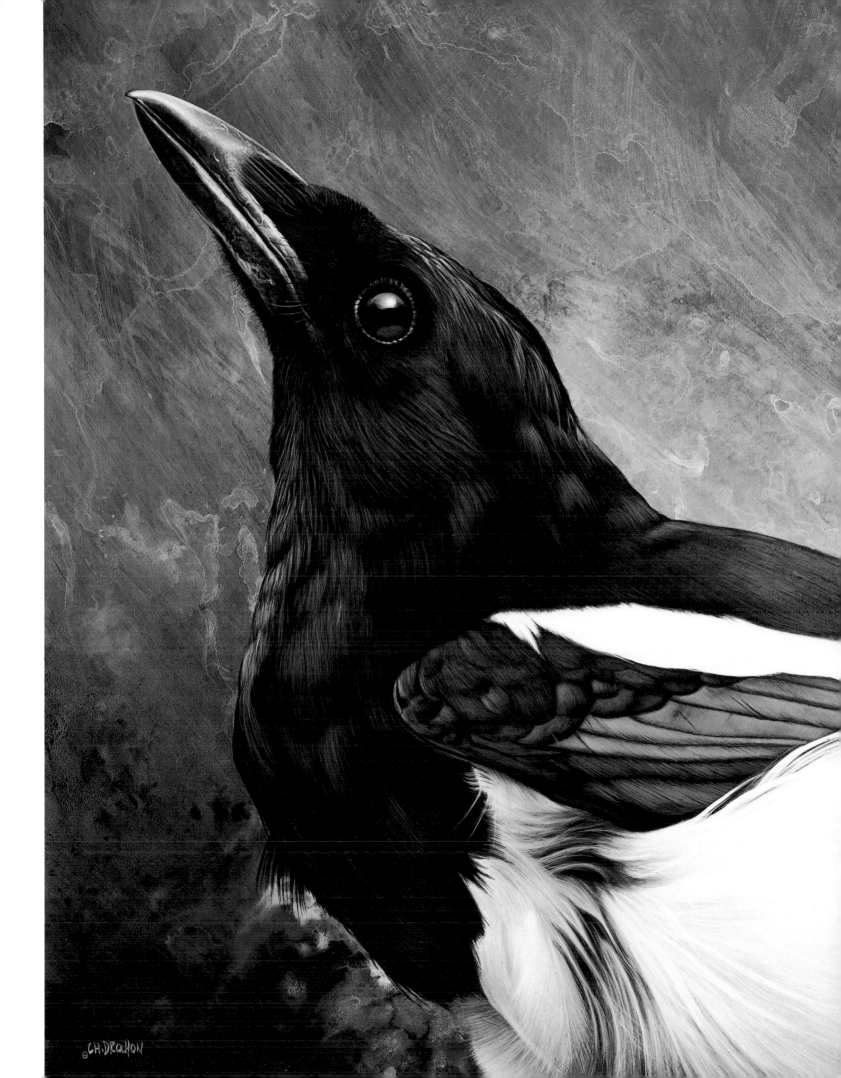

# Siska

Acrylic on canvas, 41 x 33 cm (16¼ x 13 in).

Among the various wolves observed by Christophe Drochon, this female grey wolf from Poland, named Siska, is certainly his favourite. She is the subject of several paintings (see page 39, page 46) and a lot of drawings. In this composition, the painter has chosen to frame the animal in close-up, showing it face on, with its mouth open. The wolf's gaze is deep, mysterious and tender at the same time. The little bubble of saliva that has formed at the tip of her tongue accentuates the sensitivity of her gaze. The choice of the wide format has enabled the artist to work intensely on the subtlety of the colours that dance in the fur. Browns, russets and a whole range of greys, blacks and whites are layered over and intersect one another in a tight mesh of short and long hairs. The painter works in successive layers, creating depth and relief as he goes, following the direction of the fur in each area.

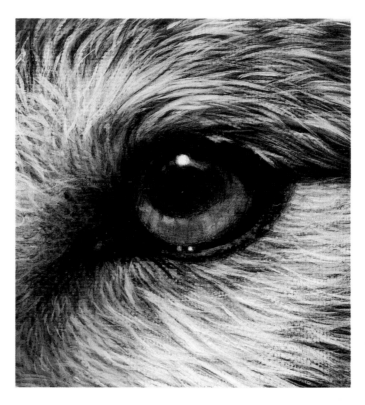

■ **The eyes**. The left eye of the wolf indicates a slight movement of the head. It is deeply set in the cavity, behind the arch of the eyebrow. The point of light at the top of the iris orients the gaze.

■ **The fur**. The thickness of the fur is revealed by the multitude of russet and grey brushstrokes, dark at first, then increasingly light.
The tufts of white hairs on either side of the muzzle create volume and show the shape of the skull.

■ **The mouth**. The damp nose, black and shiny, reveals an animal in good health. Its tongue, dark inside, is lit along the edges. A small drop of saliva appears between the fangs.

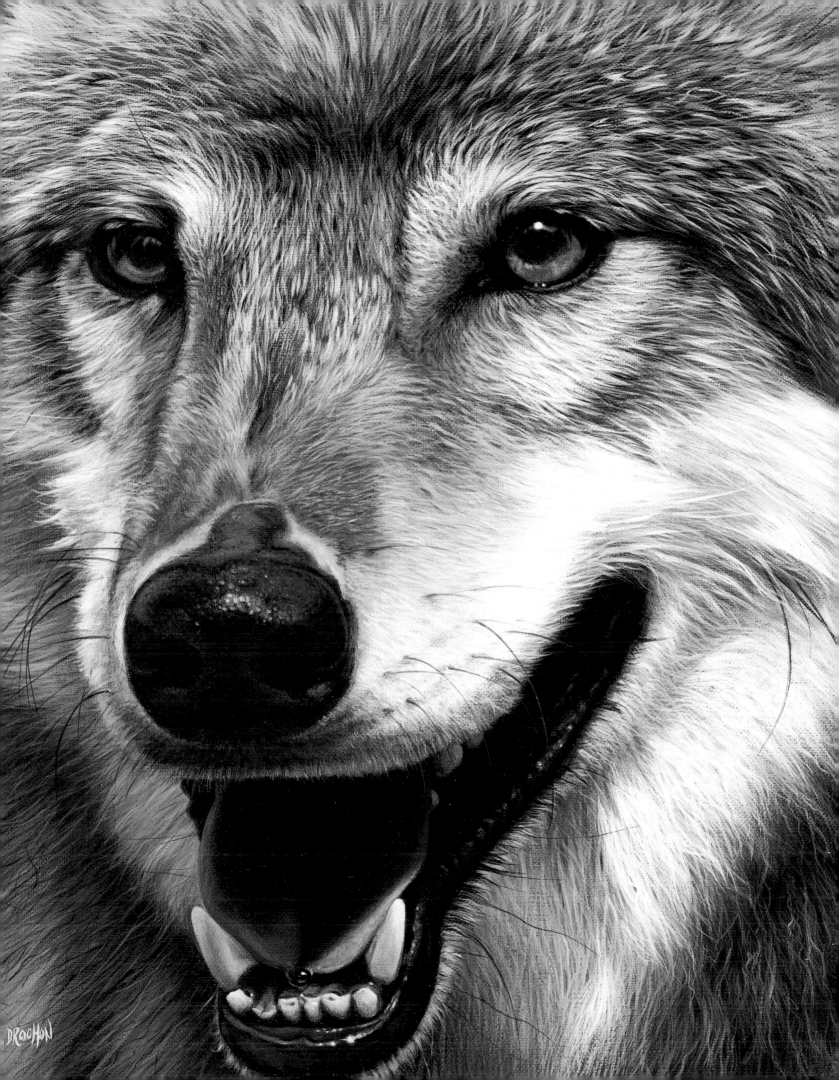

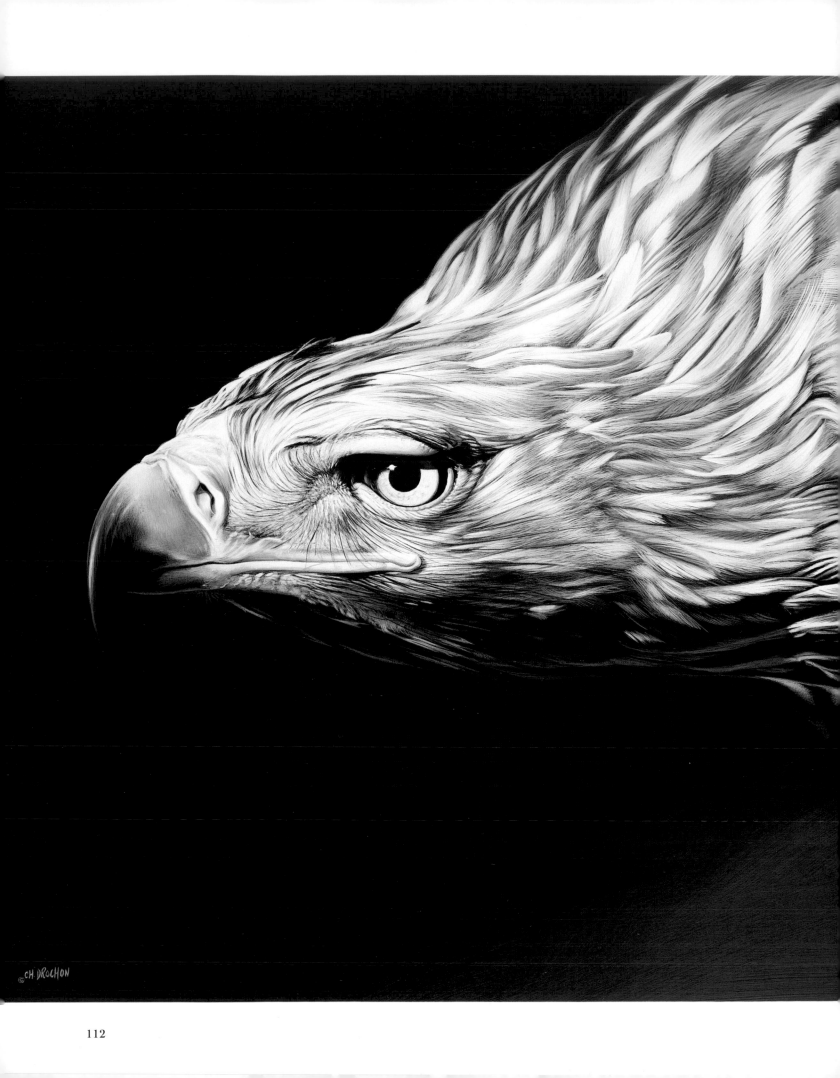

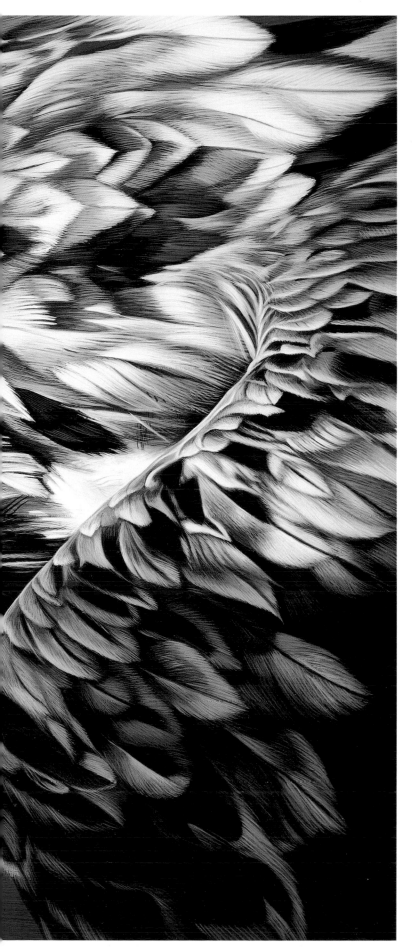

# Mahouny

Acrylic on illustration board, 36 x 51 cm (14¼ x 20 in).

The imperial eagle is a fascinating animal that rises way above the clouds and is on familiar terms with the sky. The mythical bird, forever the symbol of power and majesty, is the only bird capable of looking straight at the sun without burning its eyes. The only bird, in a way, to clash with the gods... It is this confrontation that Christophe Drochon has wanted to convey with this play of contrasts and differences.

The artist has placed the bird of prey against a particularly dark background, almost as dark as the pupil of its eye. The bird is strongly lit, and the deep shadows beneath its eyelid give depth and intensity to its gaze. Its highly characteristic bill is suggested by a light line. The light that shines on its body clothes it in shimmering golds – like a mantle of power and pride. However, the unlit area that partly covers its wing is a reminder that all power has its dark side...

■ **The feathers**. Starting from an almost black background, using fine brushes the artist reproduces the ochre, browns, blues and creamy white of the feathers, which are layered with order and precision in remarkable detail.

■ **The eye**. This is the focal point of the picture. Immersed in this piercing gaze, the viewer ends up identifying with this female eagle. And will he have the courage to face the gods in his turn?

# Full Moon

Acrylic on canvas, 33 x 22 cm (13 x 8¾ in).

A nocturnal bird, the owl is the symbol of the moon. The portrait of this barn owl contrasts dramatically with the eagle on the previous page, which has the sunlight coming directly into its open eyes. An attribute of soothsayers, the owl symbolizes the reflection that dominates the darkness.

The artist has tried to express the mystery and magic of the night that surrounds this bird. Although not represented, the moon is nevertheless omnipresent in the painting, and its light bathes the bird of prey's plumage. The sky, of an almost unreal blue, heralds the dawn. This is a resplendent night, not at all filled with anguish.

In the moonlight, the barn owl's plumage is shown in all its colours. While white dominates the head and breast, the feathers of the back and the inside of the wing are coloured reddish brown. The black eye, lit by a point of light, gives the standing bird a serene and wise meditative air.

■ **The head**. Covered with thick white down, the head is surrounded by a ruff of pinkish feathers. The black eye seems to sink in like a black bead in an immaculate cushion.

■ **The wing**. By playing on contrasts, shadows and light, the artist suggests the layers of silky feathers, worked with very small brushstrokes applied with the tip of the brush.

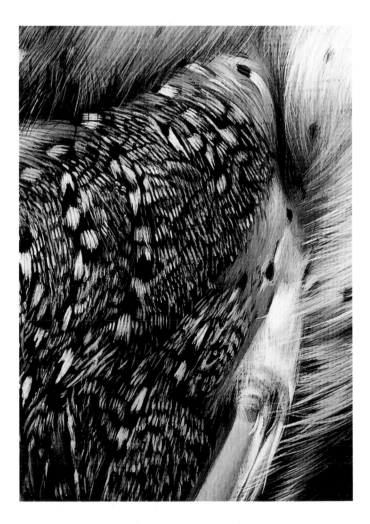

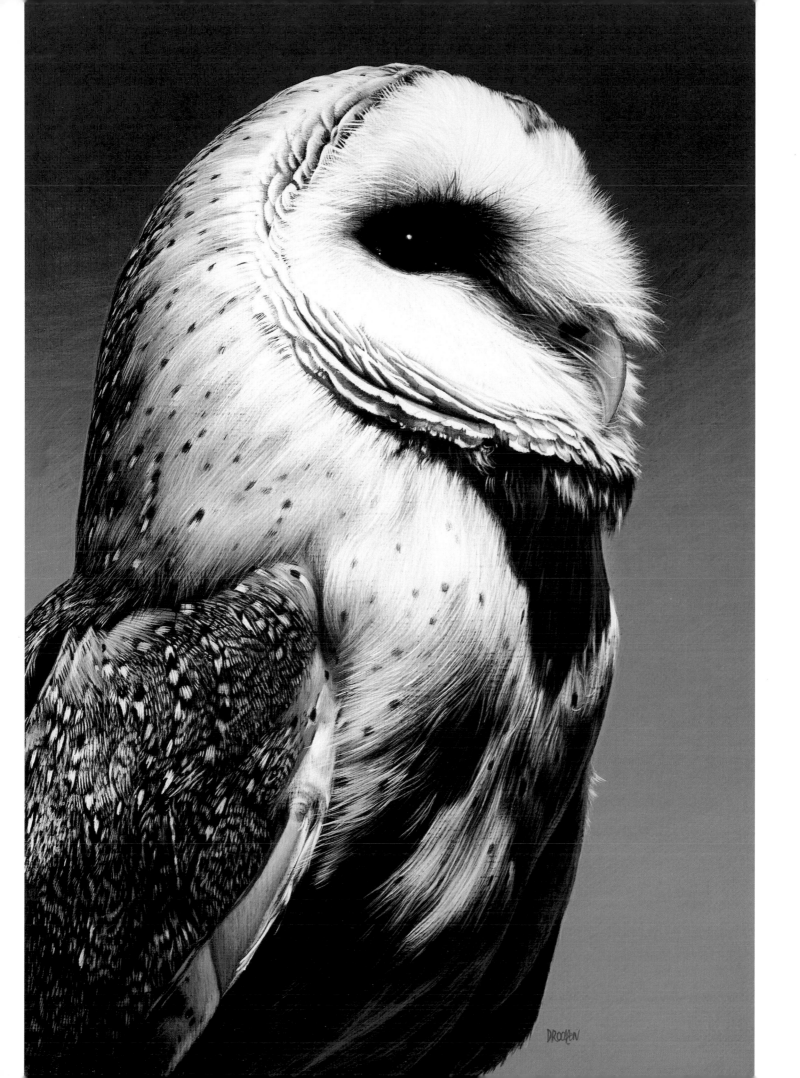

# Agile Frog

Acrylic on fibreboard, 20 x 20 cm (8 x 8 in).

You don't have to go very far to find a subject to paint. An afternoon's gardening was enough to provide Christophe Drochon with this unusual encounter with a small frog. Not very shy, rather curious and intrigued, it remained in the painter's company for a long time.

Small frog, small format. The artist has sought to set the animal in a world that corresponds to its appearance. He chose to place it on a sandstone rock, the tones and textures of which match its colours and offer a thousand shades beneath the rays of the sun. It is also a way of suggesting the proximity of the forest of Fontainebleau in France.

The drawing of the animal is highly structured: the back is clearly marked out, the head is broad and the legs fleshy. The brown, greenish and black markings on its skin allow the frog to conceal itself easily by merging with its background.

■ **The head**. What characterize the triangular head of the frog are its protruding and bulging eyes. The left eye in the foreground is partly in the shade, but the flash of light at the top of the pupil gives it all its presence.

■ **The feet**. All the frog's power resides in its legs. The alternating streaks of light ochre and black create the contours and show the volume of these limbs.

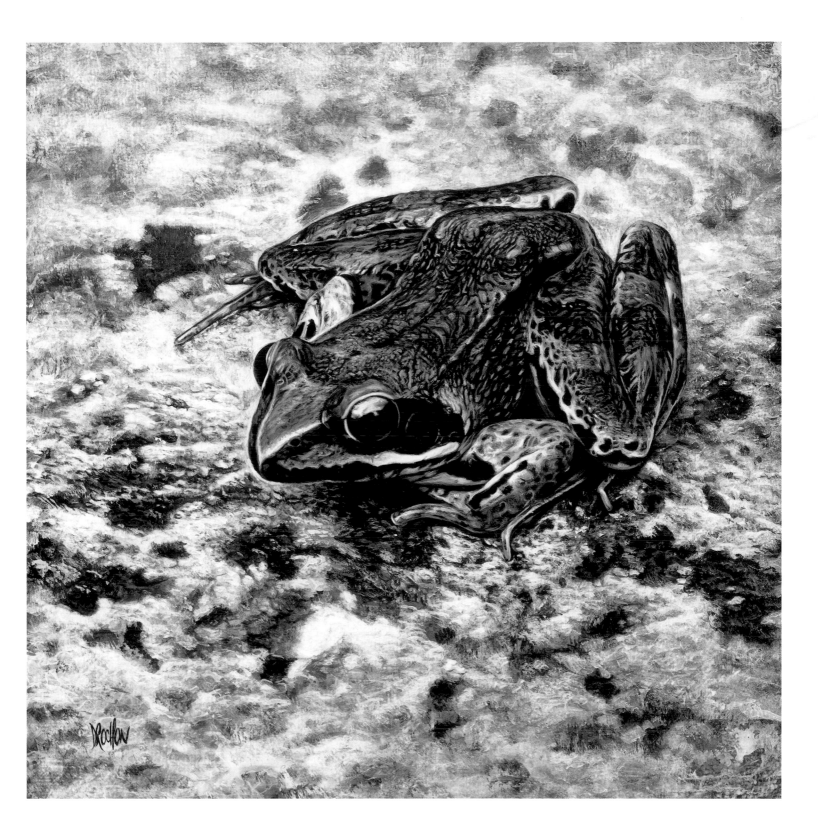

# Sam, the European Otter

Acrylic on illustration board, 27 x 37 cm (10¾ x 14½ in).

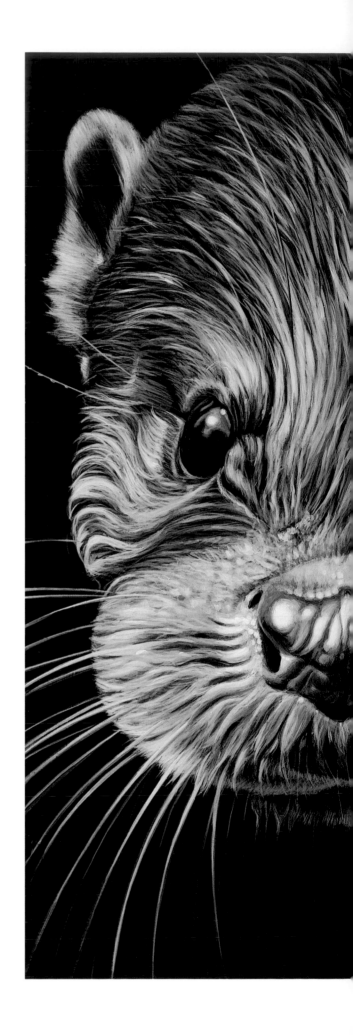

S am and Vick are two male European otters that live together in Vincennes zoo in Paris. Evidently, even in captivity, the otter remains timid. It uses the nooks and shelters provided to hide and to sleep. In general otters prefer to come out at night. It will have taken the zoo keeper six months to get them to adopt a few daytime habits! They only emerge rarely for visitors, but they do show their faces for their two daily meals. Then they eat live trout, thrown into the water course that runs through the enclosure. This gives them the illusion of hunting. Sam, less distrustful than Vick, has let his broad head and his blunt nose be seen. His eyes are bright and bulging and his ears short and round. Dense and very shiny, his fur shows lovely golden brown and silvery glints.

■ **The muzzle**. The flat damp muzzle of the otter shines in the light. Smooth touches of beige, pink and white push the nose forward.

■ **The fur**. To convey the appearance of the wet fur, the artist has painted groups of hairs coming from a bluish dark background. He has used small flexible brushes and increasingly light tints to layer rippling brushstrokes. The contrast this creates gives the fur volume.

118

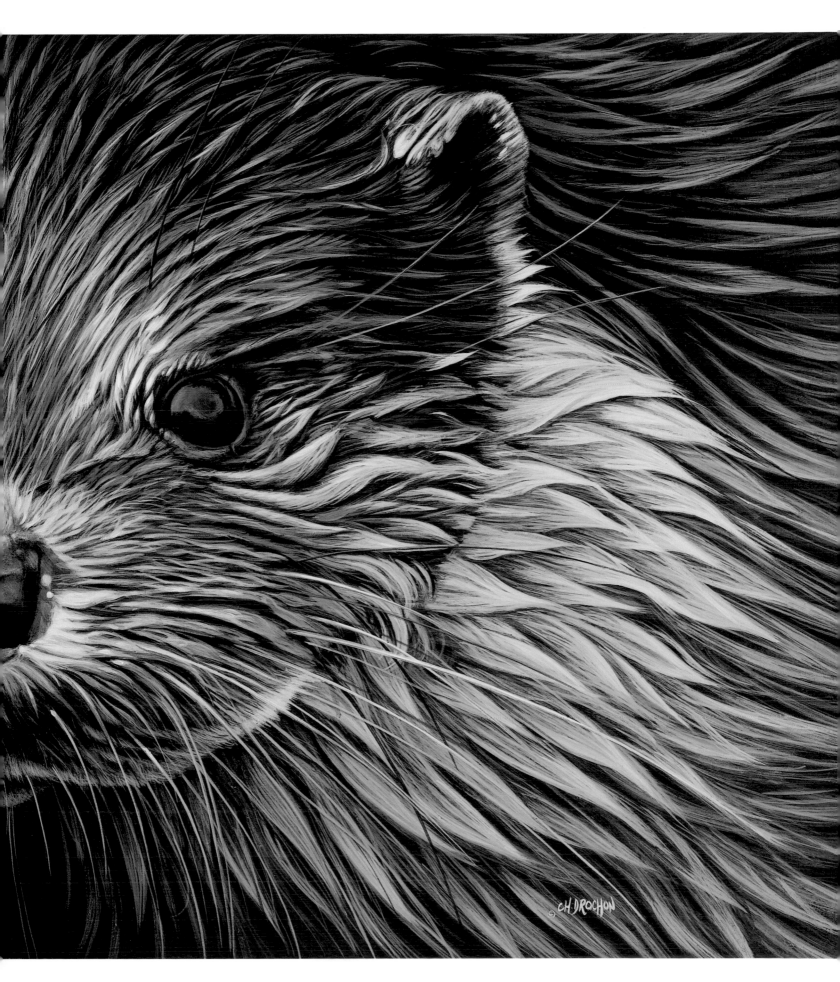

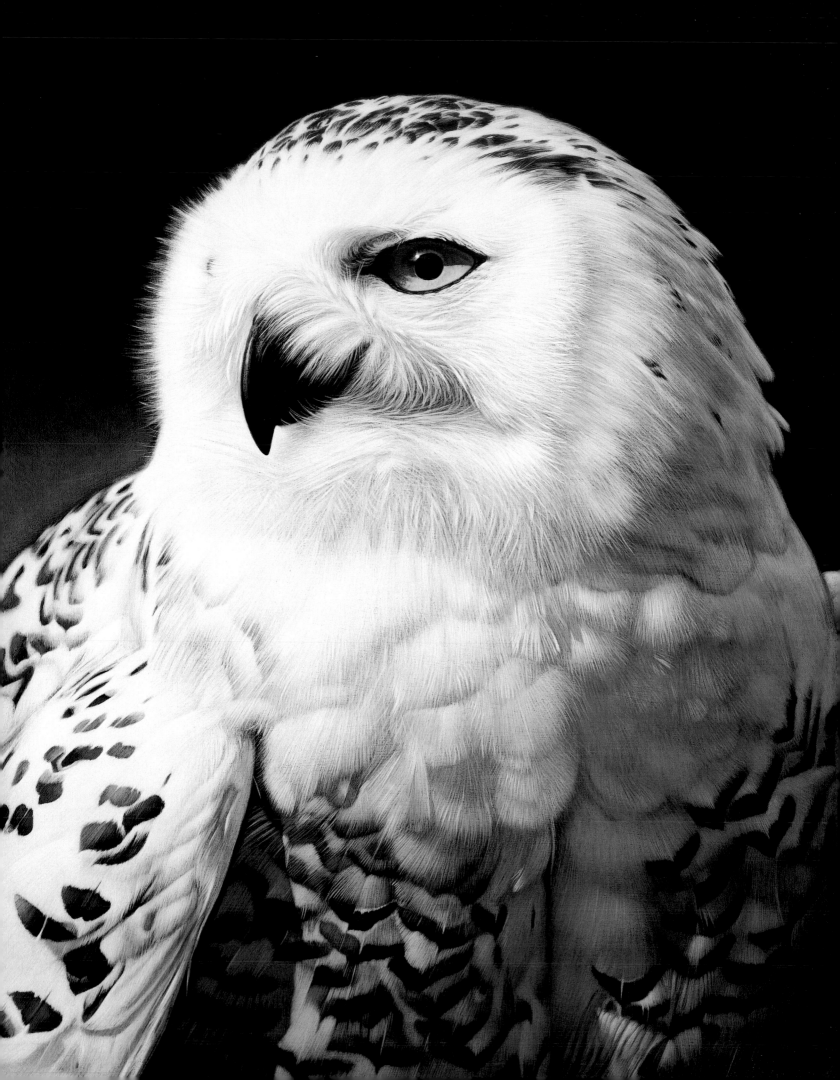

# Missi-tslatsa

Acrylic on canvas, 81 x 65 cm (32 x 25½ in).

**M**issi-tslatsa "Owl old-woman" is the name of a North-American Indian woman photographed in 1926 by Edward S. Curtis. This woman owed her nickname as an owl to her shamanistic power. Indeed, this bird of prey is the one which, symbolically, guides the spirit that progresses through the night.

Attending one of the demonstrations of birds of prey in flight that some wildlife parks hold in the summer, Christophe Drochon observed the movements of a snowy owl. The strange gaze of the bird of prey made a great impression on him. It was an obsessive idea that remained in his mind for many months, without his realizing why, until the day he came across the portrait of this shaman woman with her eyes turned towards an inner dream. In it he perceived the same spiritual fervour.

The painting came about slowly, starting with dark colours (phthalo blue, burnt sienna, purple violet) working towards pale greys, then whites. Bright yellow, shaded with a green-grey glaze, the eye is illuminated by a white point that makes its gaze yet more unfathomable.

■ **The eye**. Applied on the same plane, cold colours appear more distant than warm colours. Thus, the black pupil sinks into the yellow iris. The eye socket is edged by a dark filament, which gives the gaze depth.

■ **The feathers**. The lighting of the feathers is created by adding layers of increasingly light greys.
Of a lightly tinted white, the feathers are painted with layers of small smooth brushstrokes.

# Tiger's Eye

Acrylic on illustration board, 42 x 30 cm (16½ x 12 in).

A powerful beast, the tiger is the undisputed master of the jungle. Sure of himself, of his agility in leaping on his prey and of the beauty of his striped coat, he regards the world that surrounds him with indifference. The painter observes this perfection of nature with fascination and tries to convey his majesty by focusing on the feature that he feels to be the most impressive: the eye. In this painting, the artist has chosen to frame it in profile, in order not to place the viewer in the position of potential prey. This viewpoint also allows him to work on the area that represents the "identity mark" of each individual: the stripes of the coat, unique in each case. Surrounded by black, underlined with white and hidden in the centre of a swirl of lines that resemble so many claw marks, the tiger's eye, impassive as much as unfathomable, is fixed on a distant horizon that belongs only to him.

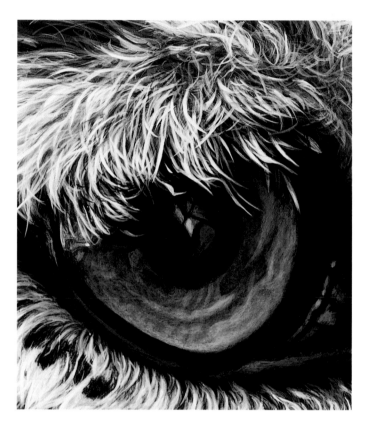

■ **The eye**. Greenish traces reflect in the golden iris like a sun: these are no doubt the leaves that surround the animal. A point of bluish light applied to the dark metallic pupil orients the gaze.

■ **The fur**. Ochre, russet and brown tones are applied in small fine and short brushstrokes to set off the stripes of the coat.

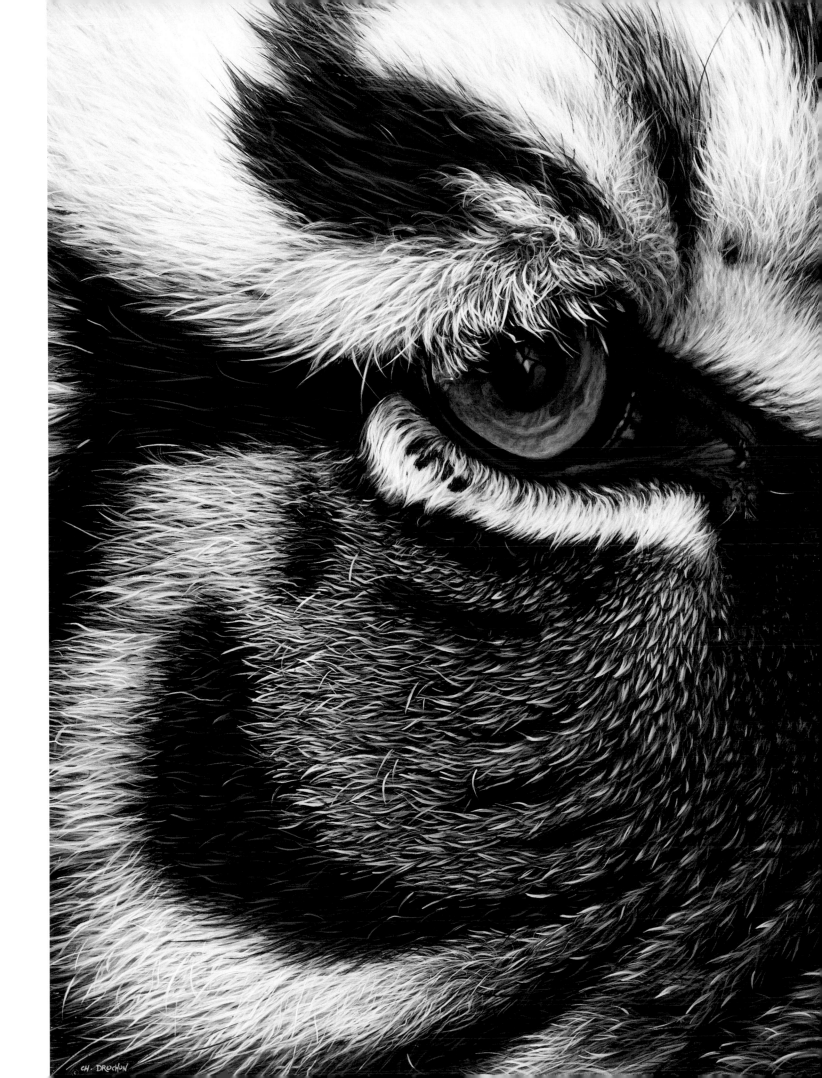
CH. DROCHON

# Chukar Partridge

Acrylic on illustration board, 37.5 x 54 cm (14¾ x 21¼ in).

I n the animal kingdom, it is birds that have the advantage of colour. In observing each species, the artist cannot help but be seduced by the abundance of graphic combinations of their plumage. And, if you look closely, the plumage of the feathered creatures of our countryside has nothing to envy that of exotic birds...

This portrait is part of a series of three paintings depicting partridges that the artist was able to approach closely in the pen of a breeder (the red-legged partridge reproduced on page 34 belongs to this group). The painter took a particular interest in the colours of their plumage. The small, round light-coloured head of the Chukar partridge is marked by a collar of black feathers that highlights its delicacy. The bill, powerful and slightly hooked, is softened by a pinkish tint.

As with the majority of birds, the partridge's eyes are on the side of its head. For this reason, the artist has chosen to frame it close up, in order to give the portrait the greatest possible presence. Capturing the full attention of the viewer, the bird's eye, dark and ringed with red, expresses the anxiety and vigilance of an animal that has always been hunted.

■ **The eye**. The prominent eye of the Chukar partridge is ringed with a roll of flesh of a glowing vermillion red. It is brought to life by a small half-moon shaped flash of light.

■ **The feathers**. The lie of the black striped feathers harmoniously surrounds the whiteness of the neck and the cheek of the Chukar partridge.

124

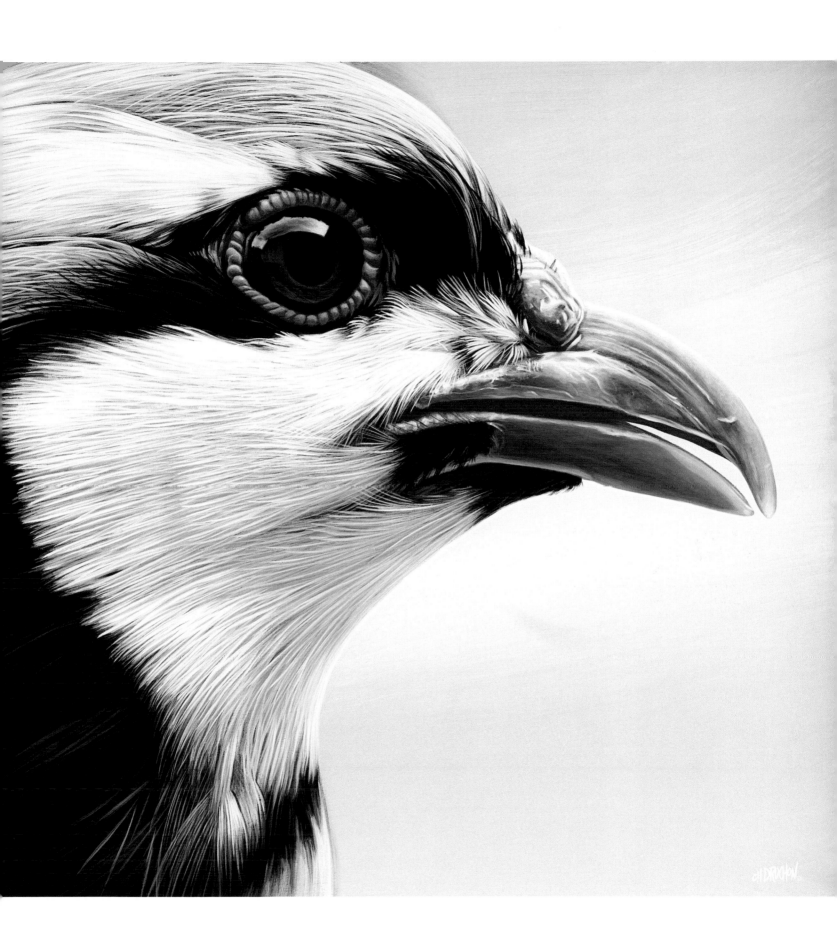

# King Lear

Acrylic on fibreboard, four panels, 28 x 29 cm (11 x 11½ in).

What other animal but the lion can symbolize and express the persecution of the animal world by man? Christophe Drochon was moved by the resignation of this "king of beasts" long ago celebrated by the writers of fables, today shut up behind bars...

This composition in four panels is therefore intended to be militant and committed. The big cat's eye slowly opens, as though after a disturbed sleep, takes in the situation he finds himself in and closes again with anger, sapped by his powerlessness. The cat is a King Lear rendered mad by the cruelty of man – but who knows whether tomorrow, in our turn, we might lose everything because we did not listen to the voice of reason... Close up, in an almost square format, the artist shows the contained strength of the gaze. The fold of the eyelids, which join together at the outlet of the tear gland, sinks deeply into the thick fur. Highlights of bluish light bring a slight shine to the mucous membranes.

■ **The open eye**. The shadow of the eyelashes softens the acuity of the gaze, which is sustained by the burst of light, obtained by a small white point applied to the iris.

■ **The closed eye**. The fur is abundant and ordered, and the shortest hairs, almost white, follow the hollow outline of the eye socket.
Above, the tuft of hairs standing up mark the arch of the eyebrow.

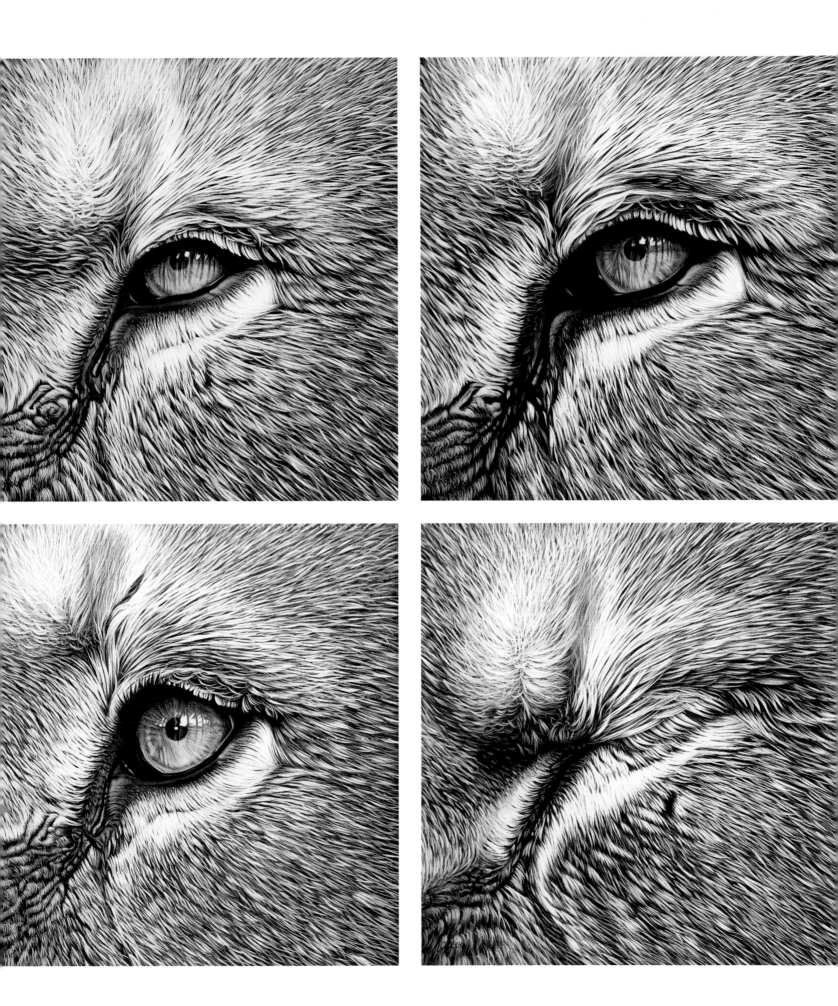